IMAGES
of America

COMPTON

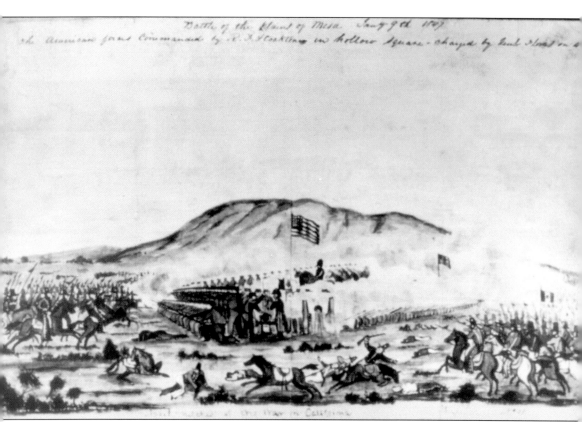

Capt. José Antonio Carrillo led 50 Californio troops in a military engagement against 200 US Marines under the command of US Navy captain William Mervine. Captain Carrillo and his men successfully stopped Captain Mervin in his attempt to recapture Los Angeles. This painting depicts that battle, known to history as the Battle of Dominguez Hills. (Courtesy of Cal State Dominguez Hills Digital Archives.)

ON THE COVER: This photograph, taken in 1962 on Compton Boulevard looking west from Alameda Street, shows a bustling downtown business district. On the left is J.C. Penney's department store next to a dentist office. Further down the street to the right at Tamarind Street is Security First National Bank. The image was taken 29 years after downtown Compton was destroyed by an earthquake on March 10, 1933. (Courtesy of Cal State Dominguez Hills Digital Archives.)

Robert Lee Johnson

Copyright © 2012 by Robert Lee Johnson
ISBN 978-0-7385-9539-9

Published by Arcadia Publishing
Charleston, South Carolina

Printed in the United States of America

Library of Congress Control Number: 2011942196

For all general information, please contact Arcadia Publishing:
Telephone 843-853-2070
Fax 843-853-0044
E-mail sales@arcadiapublishing.com
For customer service and orders:
Toll-Free 1-888-313-2665

Visit us on the Internet at www.arcadiapublishing.com

I would like to dedicate this book to my father, Robert Lee Johnson Sr., and to my mother, Gaynelle E. Cardenas. Their stories about my grandparents and great-grandparents sparked my curiosity and love of history. This book is also dedicated to my son Devin Cole Johnson, a glimpse into the future.

Contents

Acknowledgments		6
Introduction		7
1.	The Northeast Portion of the Dominguez Land Grant	11
2.	An American Town	17
3.	Agricultural Village	33
4.	Progress Equals Schools	39
5.	Water, a Blessing and a Curse	51
6.	Earthquake!	65
7.	The People	87
8.	From Town to City	97
9.	New Neighbors	113

Acknowledgments

Historians who have a direct connection with their subject are able to understand the emotion behind the history. Dr. Robert Gillingham was that type of historian; he lived the history. In the city of Compton, we are indebted to Dr. Gillingham for keeping the history and the spirit of the city alive. His notes, articles, and books are a must-read for anyone wanting to understand the city's history.

I would like to thank Gregory Williams of California State University, Dominguez Hills. The archives at Cal State Dominguez Hills are a treasure trove of information and photographic history. This is a very friendly and well-run repository. I would also like to thank Thomas Philo, who took the time to scan many of the photographs that are in this book.

In this digital age, the "library" is in the midst of reinventing itself. The A.C. Bilbrew Library is more like a community information center and Internet café, with interesting guest speakers on the weekend who are truly great community resources. I would like to thank Rose Mitchell, the Black Resource Center librarian at A.C. Bilbrew Library. She was very, very busy yet was kind and helpful.

I would like to thank Maceo Reed for the photographs from his family collection. I would also like to thank Mayisha Akbar for her photographs of the Compton Jr. Posse. Her work with the youth of the community is outstanding. The members of the Compton Jr. Posse prove that the discipline and teamwork that is inherent when working with horses and competing in equestrian events helps build successful men and women.

I would like to thank Karani Marsha Leslie for all of her support in this endeavor. Thank you, James L. Ferguson, for making this book possible. Thank you to Devin Cole Johnson for letting me see the future: my granddaughters Aaliyah Gaynelle Johnson and Alisa Loretta Johnson.

All photographs are courtesy of Cal State Dominguez Hills Digital Archives unless otherwise noted.

INTRODUCTION

For millions of years, the Los Angeles River would periodically overflow its banks and flood the coastal plain of Southern California. This made the land very fertile, and in fact some would come to call it a paradise. This book is about the city of Compton, originally part of the Dominguez Spanish land grant, and how it grew from a small agricultural town into a suburban municipality. The city once known for its prize-winning produce and livestock fast became a haven for black middle-class homeowners by the 1960s. The election of the first black mayor of a major California municipality in 1969 brought Compton unwanted scrutiny from a sensation-hungry media all too willing to work from stereotypes. Stigmatized as a high-crime combat zone in the 1970s and 1980s, homegrown gangster-rap artists solidified the myth of Compton as the home of the deprived and the depraved. As will be seen, the history of the city of Compton tells so much more.

After the Mexican-American War ended in 1848, owners of the large Spanish land grants in California felt under siege by the new American settlers. Andrés Pico, the last Mexican military leader in California, signed the Treaty of Cahuenga to end the war, an agreement with General Fremont that guaranteed Mexican landowners in California be allowed to keep their lands. With the Gold Rush and the influx of new settlers demanding land for farms, new American politicians began looking for ways to get around that agreement. One was the Public Land Commission, a panel of three Americans who reviewed the legitimacy of Spanish and Mexican land grants. Another tool was the use of taxes on the vast acreage owned by a ranchero that forced the owner to borrow money at high-interest rates. From 1850 until 1880, a vast amount of wealth was transferred from the old ranchero to new American settlers.

In February 1850, Don Manual Dominguez gave 4,600 acres, located just north of the site of the 1846 Battle of Dominguez Hills, to his favorite niece as a wedding present. By the 1860s, the same 4,600 acres was sold at a sheriff's auction. Two American investors, F.P.F. Temple and F.W. Gibson, purchased the land in December 1866. In July 1867, the first land sales were recorded to Harmon J. Higgins and John K. Morris. In September 1867, an agreement was made by Griffith Dickison Compton and William H. Morten to purchase the land that had been known as the Temple and Gibson Tract. In December 1867, G.D. Compton and other settlers arrived from Stockton, marking the beginning of the town of Compton.

Unfortunately, the settlers arrived in December during the rainy season. The town site was soon under water, and the settlers had to retreat to higher ground in the area of Central Avenue and Alondra Boulevard today. Many of the settlers wanted to abandon the town site and start fresh. G.D. Compton and William Morton persuaded the settlers to stay. Eventually the waters receded and the farmers planted their crops and prayed for the best. To their astonishment, their harvest was so bountiful that many of the settlers who had bought 40- or 80-acre farms were able to pay off their mortgages with their first harvest. With the fertile land and artesian wells, many of the farmers, who were transplants from the Midwest, thought they had found paradise.

July 1868 saw the construction of the first elementary school at the northwest corner of Alondra Boulevard (then known as Olive Street) and Willowbrook Avenue (then known as Wilmington Avenue). In May 1869, Temple and Gibson transferred 10 blocks in Compton to H.B. Tichenor as payment for construction of a railroad depot. May 1869 brought the Los Angeles and San Pedro Railroad. That June marked the opening of the first general store in Compton, owned by Max Newmark and Simon Grand on the northwest corner of Compton Boulevard (then known as Lemon Street) and Tamarind Street. August 1871 saw the construction of a two-story grammar school building on the west side of Willowbrook Avenue and one block north of Compton Boulevard, providing eight grades of instruction. On December 25, 1872, the city saw the dedication of the First Methodist Church on the northwest corner of Palm Street and Willowbrook Avenue. In July 1876, the Los Angeles and San Pedro Railroad was purchased by the Southern Pacific Company. The Anchor cheese factory, founded by J.J. Harshman, opened in April 1880 on the east side of Alameda Street (then known as Pomegranate Street) between Laurel and Myrrh Streets. May 1883 saw the founding of the Women's Christian Temperance Union in Compton and the construction of its building on the northeast corner of Culver Street and Compton Boulevard. Compton became a temperance community. The dedication of the Hopewell Baptist Church building at Tamarind and Myrrh Streets was in September 1885; Hopewell Baptist Church later changed its name to First Baptist Church. On May 11, 1888, the City of Compton became formally incorporated.

As the population of Compton grew, the need for quality schools became evident. The formation of the Compton Union High School District, one of the first school districts in the area, happened on August 11, 1896. On June 22, 1898, the first commencement exercises were held at Compton Union High School for a class of two 12th-grade graduates. In May 1900, Compton Union High School received its accreditation from the University of California. In 1903, the telephone came to Compton. The laying of the cornerstone of Compton Union High School at the southwest corner of Acacia and Myrrh Streets occurred that September. The beginning of regular instruction at the new Compton Union High School was in January 1904. That same year, the Roman Catholic Church organized Our Lady of Victory Parish in the city of Compton.

At the dawn of the 20th century, the city of Compton was at the forefront of a new technology. In January 1910, the first International Air Meet in the United States was held just over Compton's southern border at Dominguez Hills. The aviation industry would grow in the 20th century and become an economic engine in Southern California. The 20th century brought progress and setbacks, which included the disastrous floods of 1914, the first producing oil well on Dominguez Hill in 1923, the opening of the Compton Airport in 1924, the building of the first Compton City Hall on Willowbrook Avenue between Palm and Almond Streets in 1925, and the 1926 dedication of a new administration building at Compton Union High School. In 1927, Compton celebrated the opening of the Los Angeles County Health Center in the city. In September of that year, Compton Junior College began instruction on the Compton Union High School campus.

Disaster struck on the evening of March 10, 1933, when an earthquake hit Compton and the surrounding region, causing major damage to schools and the destruction of the downtown business district. The citizens of Compton rallied and began to rebuild their city. By April 1934, Compton had rebuilt its city hall. In November 1935, it dedicated a new US post office building at Compton Boulevard and Willowbrook Avenue. In March 1936, the city dedicated its reconstructed administration building at Compton Union High School and Junior College. In May 1938, the Compton celebrated the 50th anniversary of the incorporation of the city. In November 1940, it opened a second airport on Central Avenue north of Rosecrans Boulevard known as Central Airport.

At the end of World War II, many veterans were welcomed home and the baby boom began. As the population grew in Compton, the small agricultural community became a thriving bedroom community. The 1950s brought increasing progress, like the 1952 dedication of a Los Angeles County court building in City Hall Park and the building of the new campus for Compton Junior College on Artesia Boulevard. As the community grew, there was a need for a new high school,

and Don Manual Dominguez High School was opened in September 1957. As the population continued to increase, Centennial High School on Central Avenue and El Segundo Boulevard was built, serving an increasingly black student body.

The black community in Los Angeles was first centered at Fifth Street and Central Avenue in downtown Los Angeles. Over the years, it migrated south down Central Avenue, first to Eleventh Street and Central Avenue then to Forty-First Street and Central Avenue. By the 1950s, the black community had moved further down to 103rd Street and Central Avenue. After World War II, with the influx of migrants from the South seeking work in the defense industry, overcrowded housing became an issue. Segregated housing and the use of restricted covenants contributed to this overcrowding. When the US Supreme Court declared that racially biased zoning was unconstitutional, black families began to move into West Compton around Central Avenue and Rosecrans Boulevard. Other black families began to move into Richland Farms, a semi-rural area of Compton.

Unscrupulous real estate practices, such as blockbusting, encouraged "white flight." After the 1965 Watts rebellion, it became a "white panic" as white residents fled the city, causing a recession that crippled Compton's downtown business district. Crosses were burned on the lawns of black families moving into East Compton well into the 1970s. As major manufacturers along the Alameda Corridor began to shut their doors or move out of the country, combined with a hobbled downtown business district and homeowners who were saddled with predatory loans that caused many to lose their homes, Compton was quickly becoming an economic basket case. The 1969 election of Douglas Dollarhide made him the first elected black mayor of a major California municipality since 1850. This fact brought increased media scrutiny on the city of Compton.

As businesses closed, crime began to rise and gangs developed a foothold in the city. By the 1980s, the Reagan administration's foreign-policy initiatives in South America directly affected the city of Compton. Displaced citizens fleeing wars and death squads in South American countries began to change the face of Compton once more. Especially devastating was the cocaine epidemic that swept through Compton and other communities in the 1980s as a result of US foreign policy in South America. It would take decades to recover.

On May 7, 1998, Congresswoman Maxine Waters introduced into the Congressional Record a letter exchange in which CIA director William Casey engineered a legal exemption in 1982 sparing the CIA from a requirement to report evidence of drug trafficking by their assets. In July 1998, CIA inspector general Frederick Hitz concluded that in an effort to circumvent the Boland Amendment that defunded American support for Nicaraguan Contras, members of the Contras raised funds for their cause by trafficking in cocaine with the tacit support of members of the CIA. This support included quashing DEA investigations. It has been well documented that a Contra-connected cocaine trafficker named Danilo Blandon and a drug dealer named Ricky Ross, amongst others, flooded the Los Angeles area with cocaine in the 1980s. The Contra drug dealers realized that the gang structure in Compton, Los Angeles, and other cities was a natural drug distribution network and took advantage of it with devastating results. The deadly mixture of gangs, drugs, money, and guns turned many Southern California communities—especially Compton—into war zones with extensive collateral damage that will take decades to recover from.

Today, the city of Compton is replacing its aging housing stock, creating new shopping districts, and is on the move once more with the completion of the Martin Luther King Jr. Transit Center. Compton boasts an award-winning equestrian team called the Compton Jr. Posse, an internationally known cricket team, and record-setting flight students from the Compton Aeronautical Museum at Compton Airport. The city of Compton is moving into the future as a multiracial city full of promise.

One

The Northeast Portion of the Dominguez Land Grant

Juan José Dominguez, a soldier in the Spanish army, was an early explorer of what was then known as Alta California. When he retired from the army, he petitioned the Spanish government for a land grant. He received the second land grant, over 75,000 acres, issued in California in March 1784. After Juan José's death, his nephew Cristobal Dominguez was re-granted Ranchero San Pedro in 1822. Upon Cristobal Dominguez's death, his eldest son, Manual Dominguez, moved the family from the Mission San Juan Capistrano to the Dominguez adobe on the northeast side of Dominguez Hill in 1826. In October 1846, Dominguez Hill was the site of a battle between US Marines and a Californio militia. The Californio militia won the battle and denied the United States the recapture of Los Angeles.

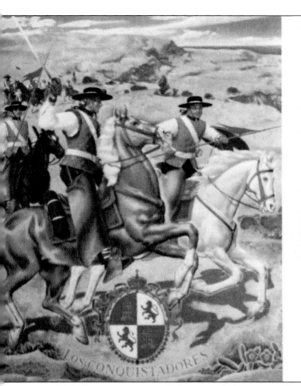

Aldo Lazzarini created this mural depicting the history of Compton and the harbor area for the Compton office of Community Savings-and-Loan. The artist was well known for his portrayals of historic events in the Southwest. These works include his mural depicting the founding of

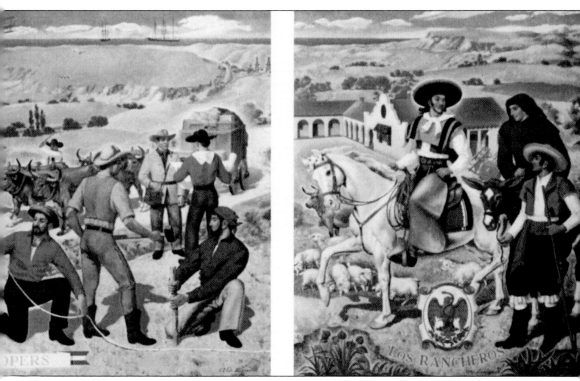

the city of Albuquerque by conquistadors in 1709 and the background painting for the movie *The Ten Commandments*. His work has been seen in the Waldorf Astoria hotel in New York, the University of Chicago, and the Essex House.

Don Manual Dominguez was the patriarch of the Dominguez family and owner of the Ranchero San Pedro. In the 1850s, he gave a wedding gift of 4,600 acres to his favorite niece on her wedding day. That land would one day become the city of Compton.

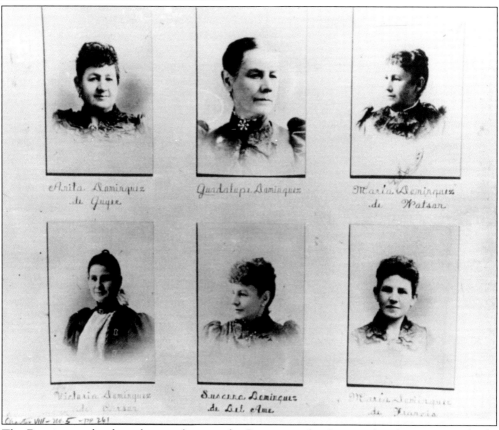

The Dominguez daughters became heirs to the Dominguez land grant after their parents' death. The borders were roughly from Rosecrans Boulevard to the north and south to Palos Verdes, with Redondo Beach to the west. To add to their fortune, oil was found on their property in the 1920s.

Members of the Dominguez, Carson, and Watson families gather at the Dominguez adobe in 1894.

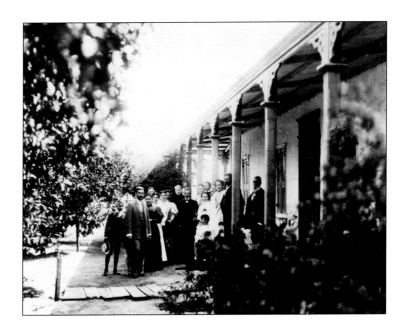

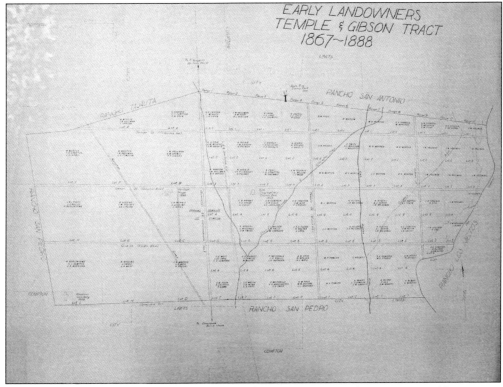

In the mid-1860s, the 4,600 acres that Don Manual Dominguez gave to his niece as a wedding present went into foreclosure and were bought at a sheriff's auction by two investors, Mr. Temple and Mr. Gibson. This area became known as the Temple and Gibson Tract and was sold to the Compton Morton party, the pioneers of Compton. The land was divided into 40- and 80-acre tracts.

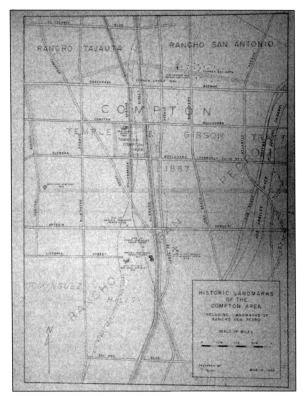

This is a map depicting landmarks in the city of Compton, including the original town site, the battle of Dominguez Hills, the site of the Dominguez Rancho house, and the site of the 1910 International Air Meet that was held in Dominguez Hills.

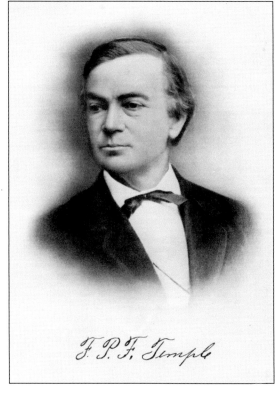

F.P.F. Temple was a major investor in land, which would later become the cities of Compton, Culver City, San Marino, Alhambra, and Inglewood. Temple was the half-brother of Jonathan Temple, who in 1843 purchased the Los Cerritos Ranchero in what is today Long Beach. He served as Los Angeles city treasurer in 1850. In 1852, Temple became a member of the first Los Angeles County Board of Supervisors.

Two

AN AMERICAN TOWN

Two American investors, F.P.F. Temple and F.W. Gibson, became owners of the 4,600 acres that had been sold at auction and renamed it the Temple and Gibson Tract. On September 7, 1867, an agreement was made between Griffith Dickenson Compton and William H. Morton to purchase the land in the Temple and Gibson Tract. On December 6, 1867, Compton and other settlers arrived from Stockton, marking the beginning of the second American town in Southern California. In the beginning, the town started as Gibsonville and then became known as Comptonville, but that name came into conflict with a town with the same name in Northern California; thus, the name was shortened to Compton, California. The original settlers bought land for farming at either 40 or 80 acres.

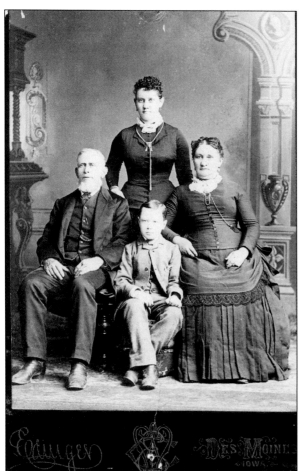

This is a portrait of G.D. Compton, his wife, Emily, and their son and daughter. Not only was Compton founder of the city of Compton, he was one of the organizers of the University of Southern California and served on its first board of trustees. He also served on the executive board of the Chaffey College of Agriculture at Ontario and owned land in what was to become the city of Rialto.

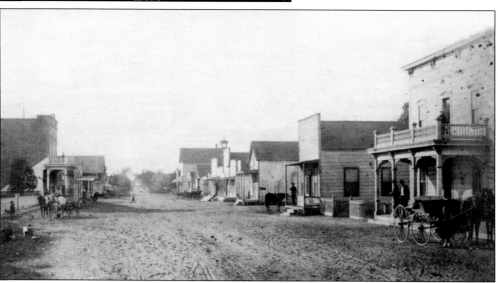

This photograph shows Compton Boulevard looking west From Alameda Street in 1885, depicting early Compton businesses, horses, and wagons on both sides of the dirt street.

Dr. Franklin Whaley was the first doctor in the city of Compton. This photograph shows Dr. Whaley in 1880. His home in Compton was close to the railroad depot where the train whistle would let him know that he was needed and should board the train immediately to render his services to the outlying areas. Dr. Walton's well-known quote was, "Every debt man owes to God is payable to his fellow man." The Franklin S. Whaley middle school in Compton is named in his honor.

This photograph shows Edwin Barron, wife Mary, and his family. From left to right are Pearl Barron Malcom, Ida Barron Ryan, Francis Edwin Barron, Emma Barron, and Mary Smith Barron. Pearl, Ida, and Emma taught in Compton schools. This photograph was taken in 1900.

Peter Y. Cool was the pastor of the First Methodist Church in Compton. The original settlers of the city of Compton were all members of First Methodist Church, making Pastor Cool a leader in the community. This photograph was taken in 1879.

This photograph shows the original First Methodist Church building at the northwest corner of Palm Street and Willowbrook Avenue. This church was dedicated on Christmas Day in 1872. This would be the future site of the Compton Civic Center.

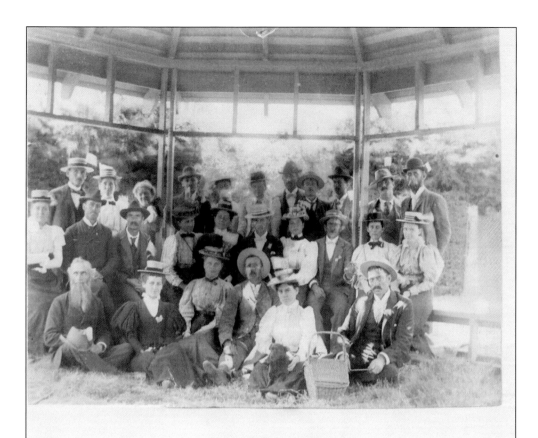

METHODIST PICNIC

FRONT ROW: 1. REVERAND A. W. BUNKER, 2. UNKNOWN
3. PEARL BARRON MALCOM 4. CHARLES HEATH 5. BELLE
BUCKHAM KOHLER 6. TOM NEECE
SECOND ROW: 1. MRS. SAM BUCKHAM 2. SAM BUCKHAM
3. UNKNOWN 4. IDA BARRON RYAN 5 - 9 UNKNOWN 10. MINNIE
BUCKHAM
TOP ROW: 1. CHARLES SOLAN 2. NETTIE DINSMORE SLOAN
3. - 7 UNKNOWN 8. NELLIE LEACH 9. MR. SNAVELY 10. IRMA
BUNKER SNAVELY 11. MINNIE WELSH TAYLOR 12. ARCHIE TAYLOR
13. HAROLD MASON 14. LEE SHEPARD 15. ALEX DURWARD

Members of the First Methodist Church have a picnic under the gazebo in 1890. Many of the last names of those in the photograph are now street names in the city of Compton.

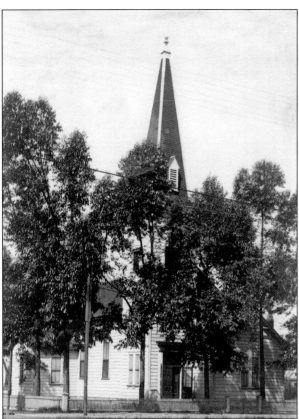

This photograph shows the First Methodist Church on the corner of Palm Street and Willowbrook Avenue in 1906. The area would later become the site of the Compton Civic Center and Post Office.

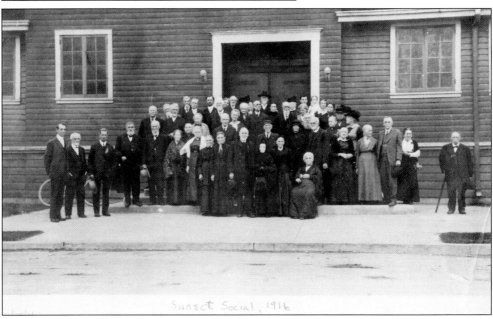

Pictured is the First Methodist Church Sunset Social, a group of men and women who were early pioneers in the city of Compton. Members are gathered in front of the First Methodist Church building in 1916.

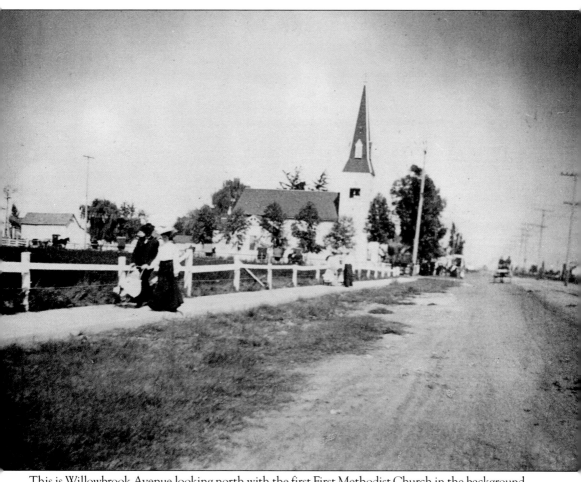

This is Willowbrook Avenue looking north with the first First Methodist Church in the background and a well-dressed couple walking with their child in a stroller in 1905. This area would later become the Compton Civic Center.

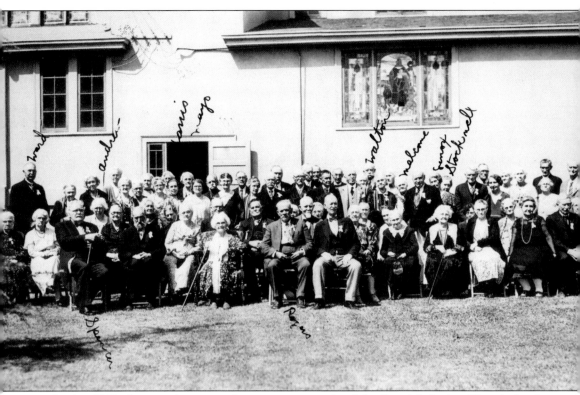

In this 1940 photograph, men and women are outside of the First Methodist Church for the Sunday social. Those marked include members of the Ward, Spencer, Andrew, Harris, Mayo, Rogers, Walton, Malcolm, Lenox, and Stockton families.

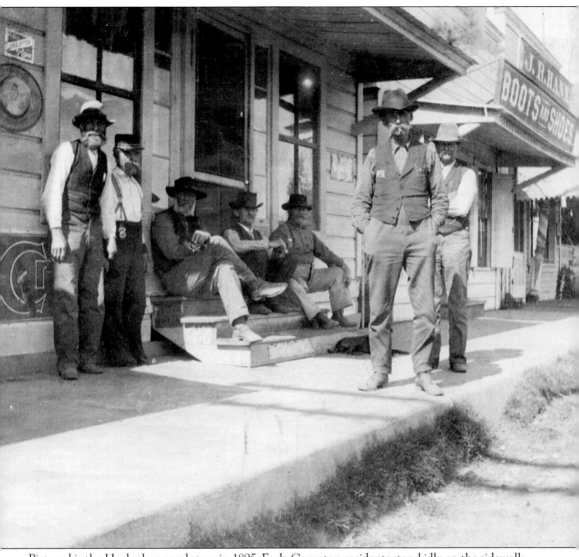

Pictured is the Haylock general store in 1895. Early Compton residents stand idly on the sidewalk and steps outside of the general store and J.R. Hann Boots and Shoes. This is where the men would meet to discuss politics and current events.

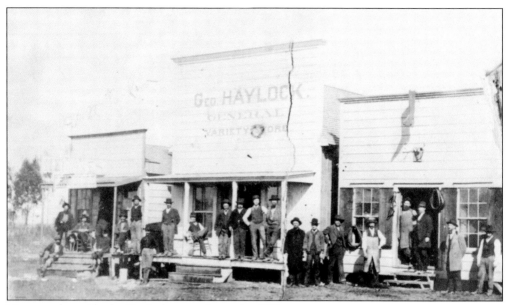
Men stand outside the Haylock general store in 1895.

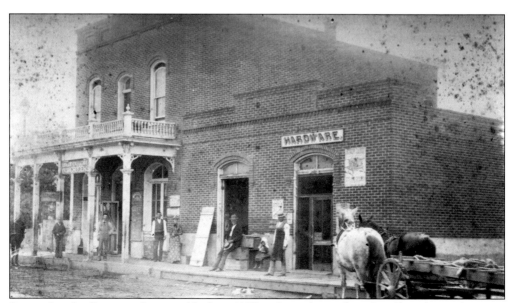
Pictured is the Compton business block in 1887 and people on the sidewalk in front of grocery and hardware store with horses and carts parked in front.

This photograph shows Compton Boulevard looking west in 1888 with the Haylock general store on the right. The railroad intersection is far in the background. A man is crossing the street, and flooding is visible on each side of the street.

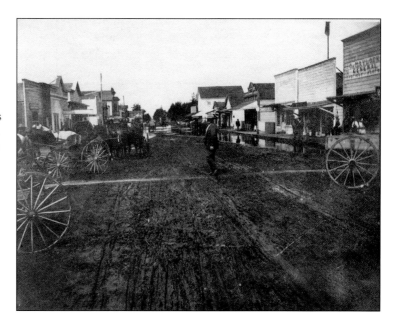

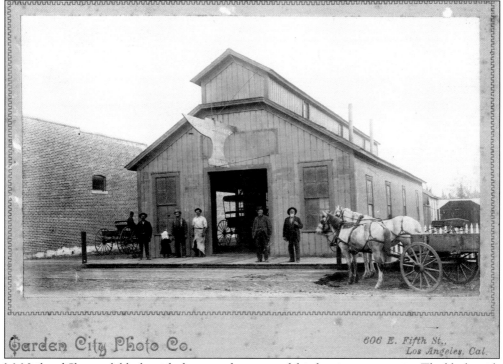

McNeil and Shawrack blacksmith shop was the center of this farming community. The blacksmith shop was on Compton Boulevard west of Tamarind Street. The men in front of the store are, from left to right, George Rogers, William Shawrack, Dick Heichew, Alan Kent, and Lewis Page Sr. The bull-shaped sign reads, "Compton Carriage Company blacksmith." This photograph was taken in 1895.

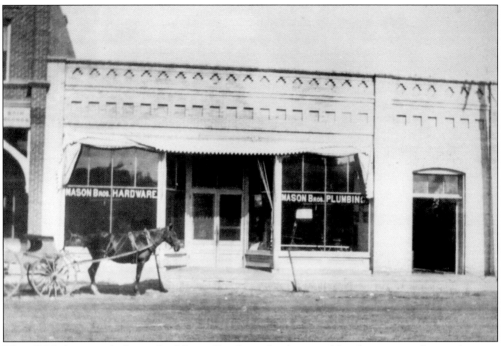

This 1906 photograph shows the Mason Brothers plumbing and hardware store. Located on the north side of Compton Boulevard, the hardware store was essential to farmers in the area.

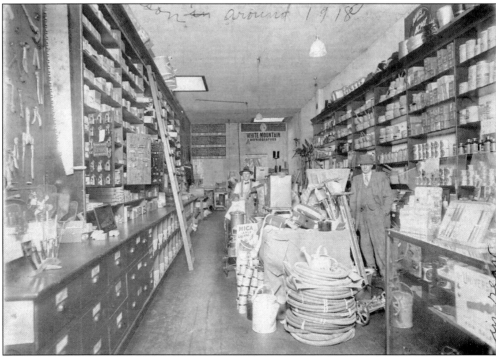

Here is the inside of the Masons Brothers plumbing and hardware store in 1918. Charles Mason is on the right and Frank Mayo is on the left stocking the store, which included hoses, tools, padlocks, and cabinet handles.

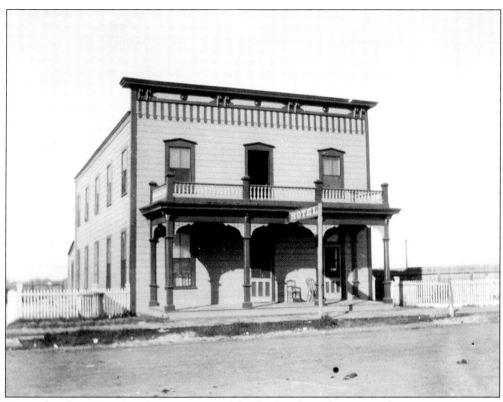

Pictured is the McKee hotel in 1894, one of the few hotels in the area at the time.

Compton was the city where one could build his or her dreams. Here, an early entrepreneur is standing in front of his store at 100 East Main Street, later known as Compton Boulevard. He was selling snacks, drinks, and tobacco products. The Pacific Electric tracks are on the right. This building was still standing in the 1960s and was used as a secondhand store. This photograph was taken in 1914.

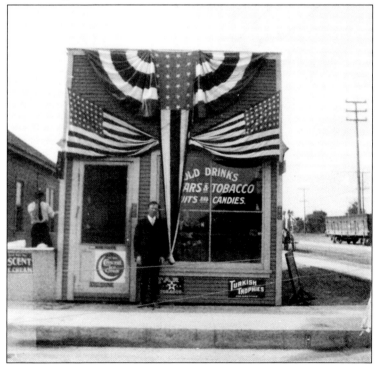

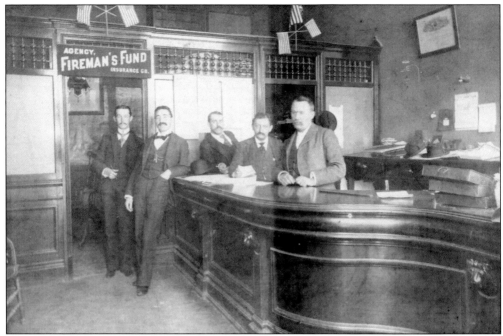

This is the office of Newmark and Edwards grain dealers. Many new businesses came to downtown Compton in support of the agricultural industry. This photograph was taken in 1890.

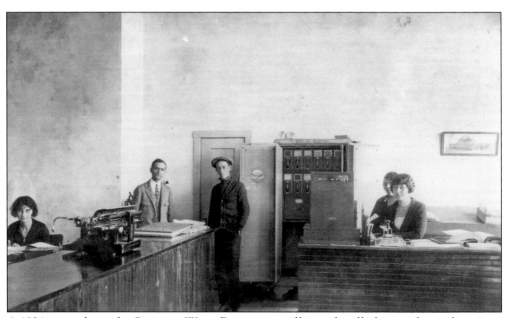

A 1924 image shows the Compton Water Department office and staff, along with a cash register, typewriter, and filing cabinet.

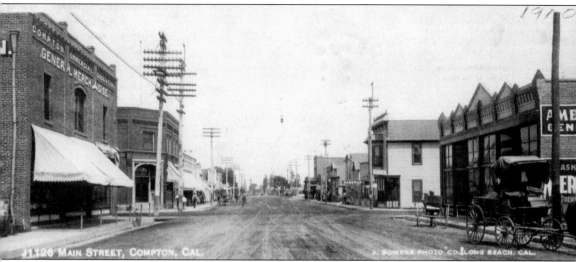

This picture taken in 1900 shows Compton Boulevard looking west to Willowbrook Avenue. There are general stores and carriages on either side of the street.

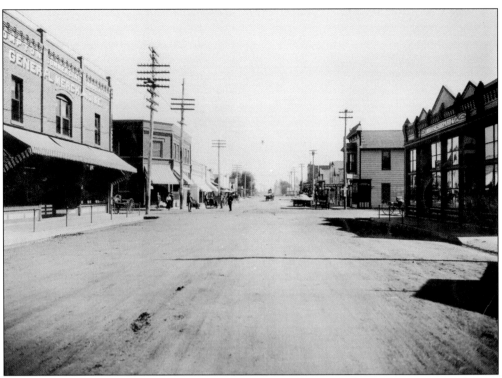

This photograph shows Compton Boulevard at Tamarind Street looking east past general stores and businesses. Compton Boulevard was still a dirt road at the time of this 1915 image.

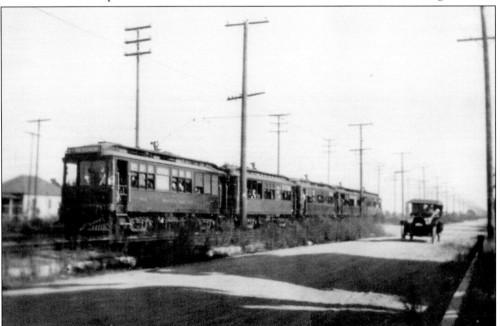

Pictured is the Pacific Electric Railway train next to a car on Willowbrook Avenue in 1914. Compton had two railroads that ran through the city. At this time, Compton was a one-day walk from the harbor and one-day walk to downtown Los Angeles, making it the "hub city."

Three
AGRICULTURAL VILLAGE

The original settlers who came by wagon train from Stockton were surprised at how fertile the land was in Compton. For millions of years, the Los Angeles River would flood land that would later be known as the city of Compton. This made the land some of the most fertile in the state of California. When the original settlers put in their first crops, they were astounded by the size of the harvest, which enabled many of the farmers to pay off their mortgages in the first year. Compton ranchers and farmers for years would take home the top prizes for produce and livestock at the county fair. It was known for its squash, pumpkins, sugar beets, and alfalfa. There was even an apple grove in East Compton.

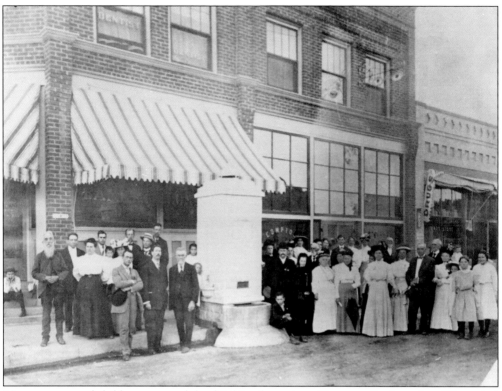

Men, women, and children surround the drinking fountain at Compton Boulevard and Tamarind Street, which was the future home of Cut Rate Drugs (on the right). This photograph was taken during the 1912 water fountain dedication.

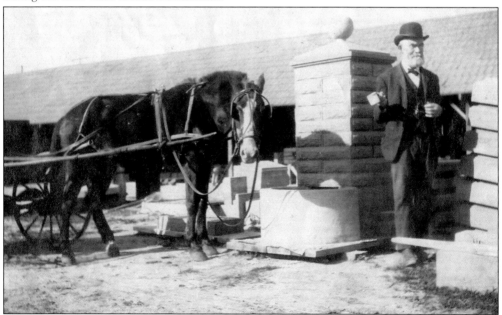

Pictured here is Benjamin Watts at the water fountain before it was moved to Compton Boulevard with a horse and cart. This photograph was taken in 1912.

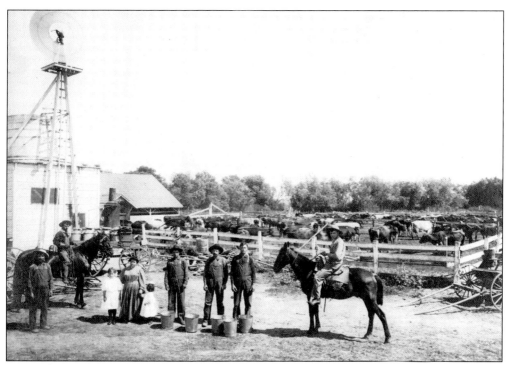

Pictured in 1908, the Carson estate company's dairy farm, near Elfman station in Compton, shows workers standing in front of milking buckets and riding on horseback in front of a corral holding many dairy cows.

A 1916 photograph shows alfalfa harvesting on what is now Long Beach Boulevard south of Alondra Boulevard.

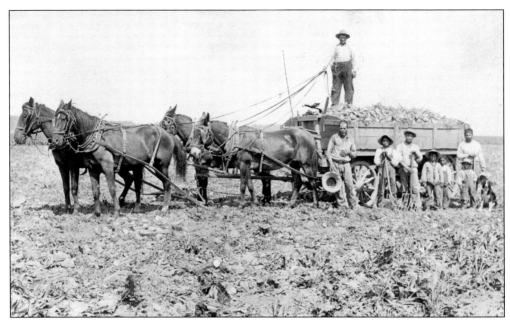

Compton was well known for having the best produce in the area with fertile land and abundant water. It seemed that one could grow almost anything in the area. This 1910 photograph is of a wagon loaded with sugar beets with farmworkers posing for the camera.

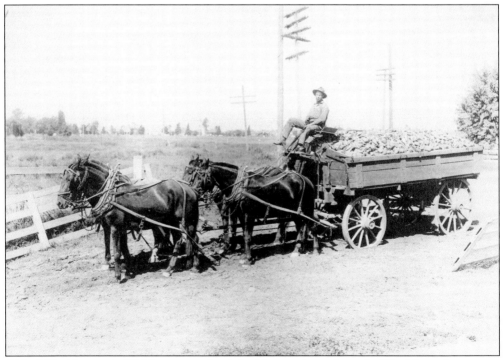

Alfred Ward is seen in 1910 in a wagon loaded with sugar beets from the Ward farm that was on Artesia Boulevard. Electric and telephone poles in the background herald the progress that will change Compton from a small agricultural town into a thriving city.

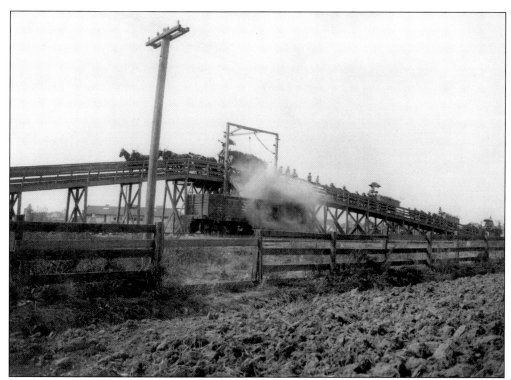

This 1910 photograph shows a beet dump in Compton where farmers emptied wagons of sugar beets into Southern Pacific Railroad cars. The dump was located at Alameda Boulevard and Myrrh Street. Fertile land, artesian wells, two railroads, a port at San Pedro, and another port at Redondo Beach made Compton an ideal home to many farm families.

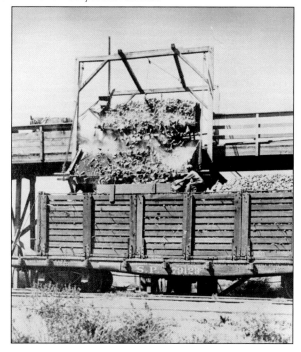

Tons of sugar beets, apples, squash, alfalfa, pumpkins, and dairy products were shipped out of Compton on one of the two railroads that ran through the city. This 1910 photograph of sugar beets being dumped into a Southern Pacific Railroad car is indicative of the bountiful harvests enjoyed by local farmers.

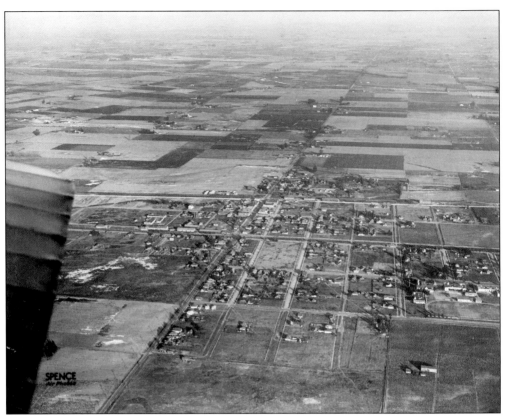

This aerial 1920 photograph looks east over Compton and shows Compton Boulevard. In the center is Compton Union High School and Junior College, and Ramsaur Stadium is in the lower right. The image shows that Compton was a large farm community with a high school and college on the same campus. There was a small downtown, but the land was mostly for farming.

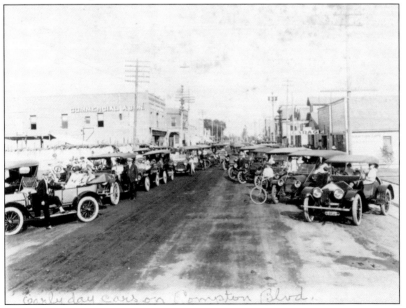

This view looks west on Compton Boulevard, and cars are parked on either side of the street. The photograph was taken in 1912.

Four

Progress Equals Schools

In early Compton, one of the signs of a growing community was the development of a public school system. Some of the first public schools in the area were in the city of Compton, and students would come from farms and neighboring communities to attend them. The construction of the first elementary school building took place in July 1868 on the corner of what is now Alondra Boulevard and Willowbrook Avenue. This was just months after the organization of the First Methodist Church in Compton. In August 1871, construction of a two-story grammar school building was completed just north of what is now Willowbrook Avenue and Compton Boulevard (on School Street). In September 1891, ninth-grade instruction began at the school. In August 1896, the formation of the Compton Union High School District made Compton one of the few cities with an organized school district.

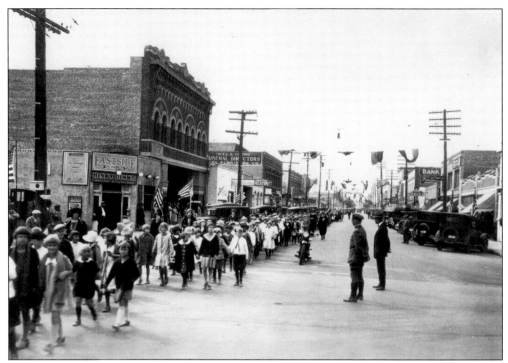

Children parade down Compton Boulevard in 1925, possibly celebrating Armistice Day or the paving of the boulevard. In the background is the east side Hinky Dinks, where one could get a hot or cold sandwich and a piece of pie for lunch, stop at the barbershop, maybe play billiards, or enjoy the Compton Theater. One could also stay at the hotel or stop in at the café at the end of the street.

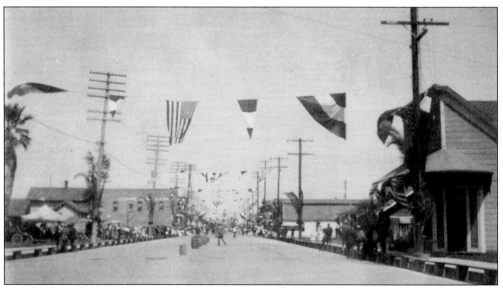

This 1916 photograph looks east down Compton Boulevard and shows the street decorated with flags. The Compton Commercial Association building is on the left. The community is celebrating the paving of Compton Boulevard, as residents were no longer worried about being stuck in the mud in the rainy season or the dust during the summer. Compton was growing.

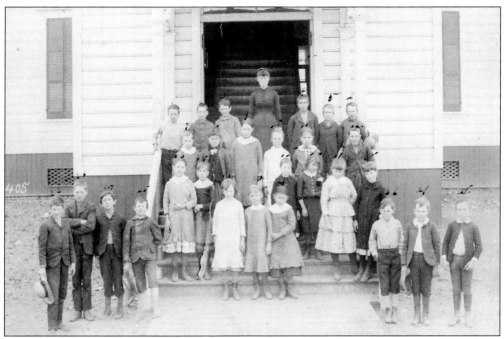

Students gather on the front steps at Compton Grammar School in a class 1886 photograph. Members of the Lathrop, Malcom, Rice, Bise, and Barron families are in the picture.

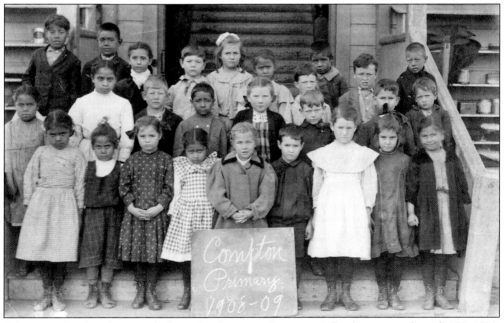

Taken in 1908, this photograph shows the Compton Grammar School's primary class of 1908–1909. They are on the steps of the original school building with their lunch boxes and hats on shelves in the background.

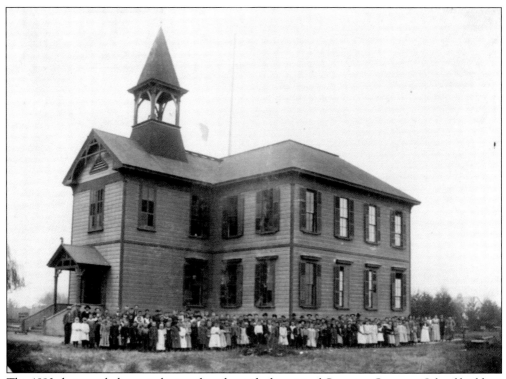
This 1890 photograph shows students gathered outside the original Compton Grammar School building. The school is at the corner of Willowbrook Avenue and what would become School Street.

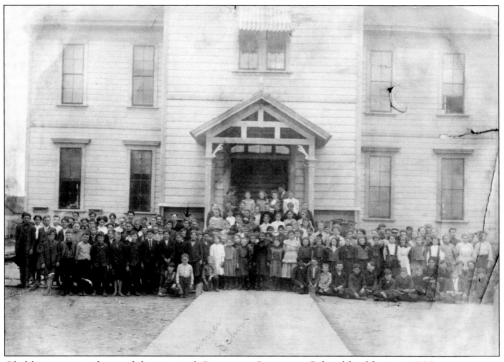
Children pose in front of the original Compton Grammar School building in 1900.

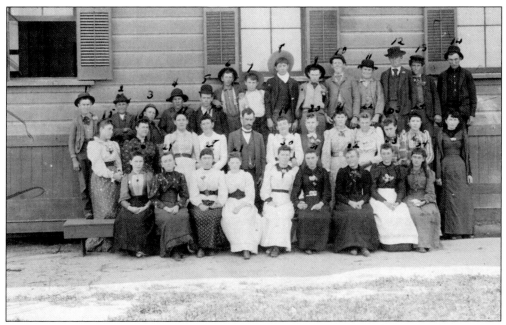

This 1890 photograph shows a male teacher in the center of the second row outside Compton Grammar School. Also pictured are members of the Malcom, Barron, Cressey, and Lathrop families, the pioneer farm families of Compton.

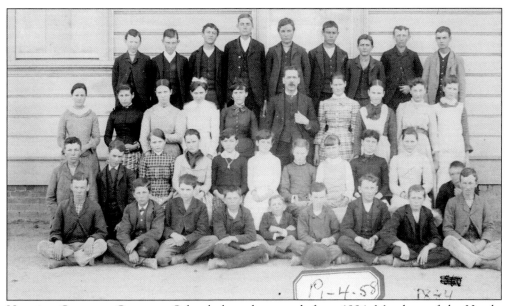

Here is a Compton Grammar School class photograph from 1884. Members of the Heath, Skilling, Buckham, Hann, and Morrison families are pictured with Mr. Damon, the teacher, in the center.

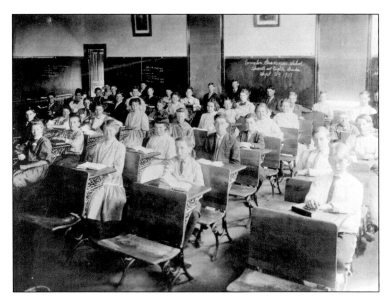

Compton had a grammar school with grades seven through eight in one classroom in 1908. Future Compton historian and civic leader Robert Gillingham and classmate Carl Shepherd are among the students pictured.

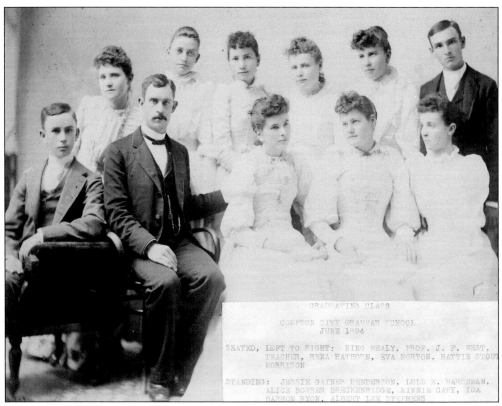

This is the graduating class of Compton City School in 1894. Pictured from left to right are (front row) King Mealy, Prof. J.F. West, Rena Hathorn, Eva Morton, and Hattie Stout Morrison; (back row) Jessie Gaines Henderson, Lulu E. Harshman, Alice Bowser Breckenridge, Minnie Caty, Ida Barron Ryan, and Albert Lee Steve.

A Sunday school group of the First Methodist Church poses in 1906; these are the Methodist Delta Alphas. Pictured are members of the Lee, Barron, Palmer, and Renfro families.

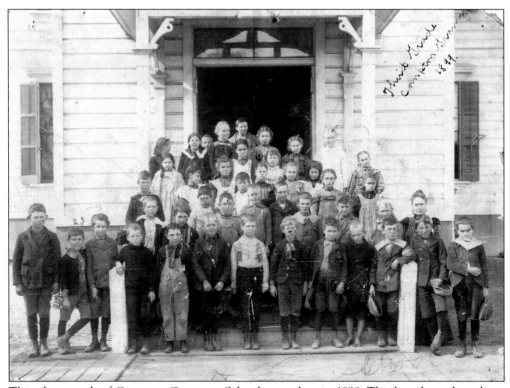

This photograph of Compton Grammar School was taken in 1899. Third-grade students have gathered at the front entrance of the original school building.

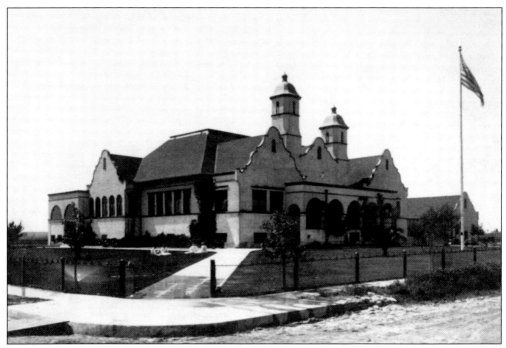

As Compton's population grew, the need for more schools was answered with the Compton Union High School building in 1904. This photograph was taken in 1909.

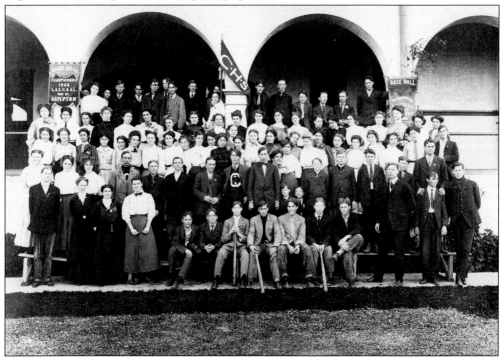

A 1907 class photograph shows students on the bleachers in front of Compton Union High School. For years, it was the only high school in the area, and students came from miles around in order to get an education.

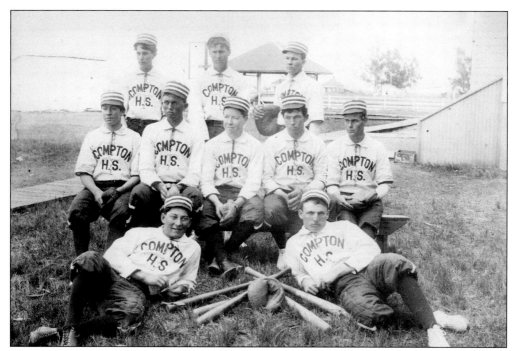

This is the Compton Union High School baseball team in 1905. The surnames Hathorn, Abbott, Steel, and Walton associated with this team are well known by anyone who reads the street signs in the city of Compton.

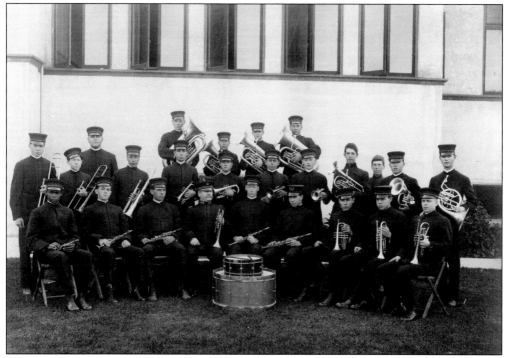

Pictured here is Compton Union High School band in 1913. The boy with the piccolo is Elijah Ward, who had an interesting role in the senior play (see page 51).

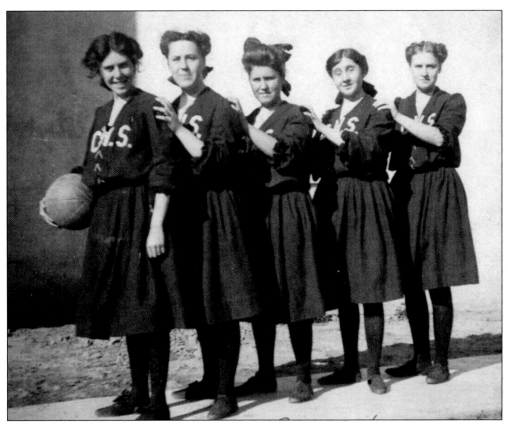
This 1905 photograph shows the Compton Union High School girls' basketball team. Pictured from left to right are Laura Gaines, Ida Barron, Alice Mathieson, Myrtle Tucker, and Grace Barron. These last names can all be found on street signs in the city of Compton.

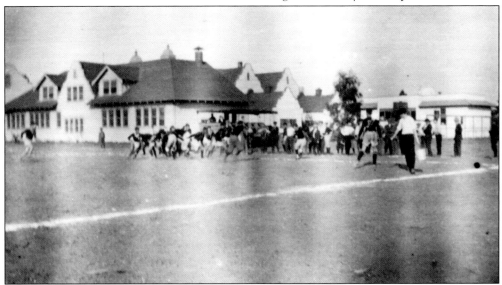
A football or rugby game is seen here in progress in 1900, with Compton Union High School in the background.

Pictured here is the Compton Union High School boys' baseball team in 1913.

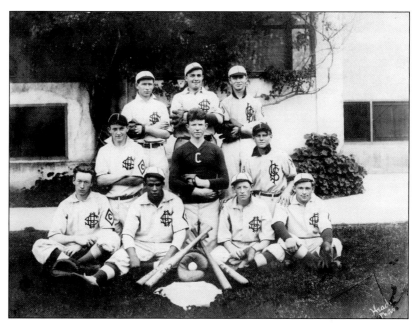

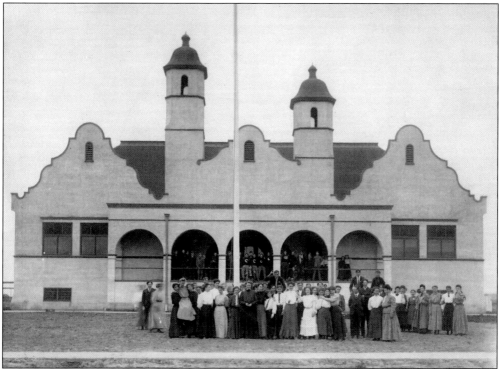

The Compton Union High School class of 1906 gathers on the front steps of the school. This picture was taken in February 1906. Little did the students know that within two months after this picture was taken San Francisco would be destroyed by an earthquake. That same month of April, a black man named Reverend Seymour sparked what would later become known around the world as the Pentecostal movement. The Azusa Street Revival would give birth to two churches: the Church of God in Christ, a black-led church, and the Assemblies of God, a white-led church.

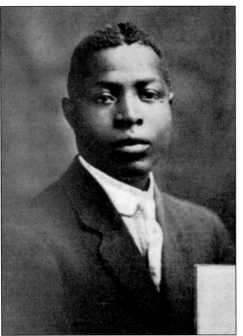

Elijah Ward, class of 1914, was one of the few black students who attended Compton schools. One wonders what it was like for him to attend high school in the city at that time. He played piccolo in the school band and participated in athletics and the school play.

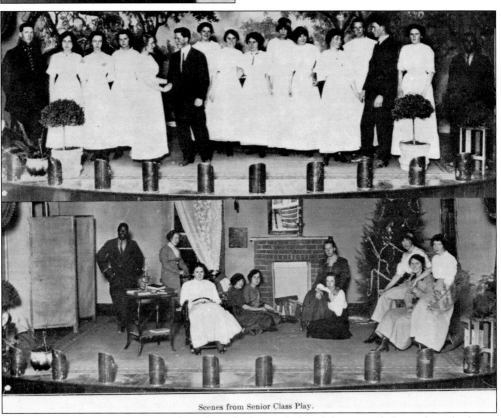

Scenes from Senior Class Play.

These are scenes from the senior class play. Elijah Ward played the part of Shiny, described as "a lazy shiftless darky." It makes one wonder who else was up for the part.

Five
WATER, A BLESSING AND A CURSE

The Los Angeles River would periodically flood the coastal plain, leaving behind fertile topsoil. This was great for farmers except when it would actually flood. Roads, barns, and even homes could be washed away in the floodwaters. For years, the only thing that the citizens of Compton could do was endure. It was not until the 1950s that the Army Corps of Engineers encased the Los Angeles River in concrete as it passed through Compton. Storm drains and concrete enclosures of Compton Creek would begin to alleviate the worst of the flooding by the 1960s. Many lives and property were lost in the meantime.

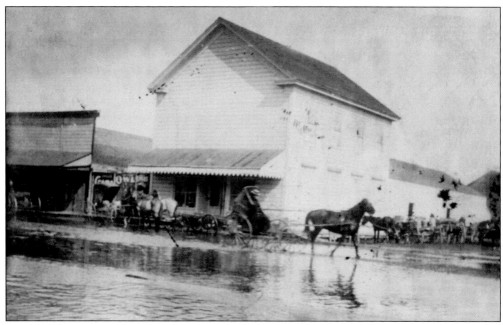

The secret to Compton's fertile soil was the periodic flooding of the Los Angeles River onto the coastal plain. This 1887 photograph shows horses and buggies at McNeil's blacksmith shop on the flooded corner of Compton Boulevard and Tamarind Street.

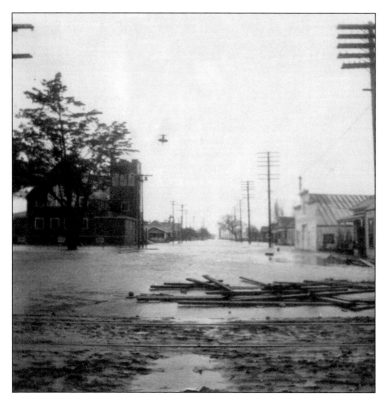

The camera looks west on Compton Boulevard from Willowbrook Avenue. The First Methodist Church is on the left and will one day become the site of the Compton Post Office. In the lower portion of this image of the 1914 flood, the Pacific Electric Railroad tracks can be seen.

The 1914 flood put most of the Compton town center under water. This photograph was taken in 1914 and depicts Palm Street looking west from Willowbrook Avenue. The area will one day become the site of the Compton Civic Center.

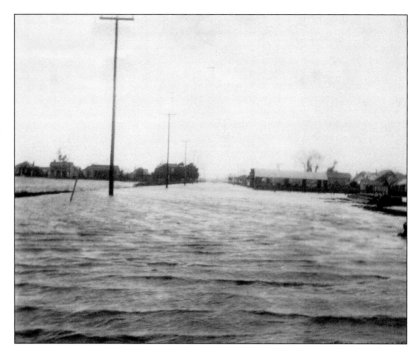

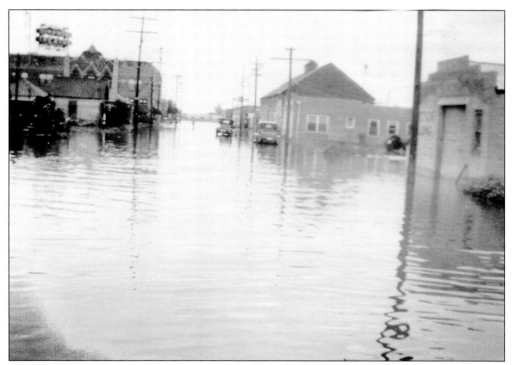

A 1914 photograph shows a flooded Magnolia Street looking east from Willowbrook Avenue to Alameda Street. To the left are the Aranbe Hotel and the Symphony Theatre, which would be destroyed in the 1933 earthquake.

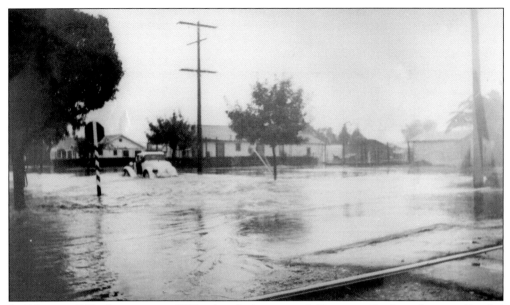

In February 1937, the area near Willowbrook Avenue and Compton Boulevard was so flooded that vehicles got stuck in the water. The periodic flooding that made farmland in Compton so fertile became a curse as the farmland transformed into a suburban city.

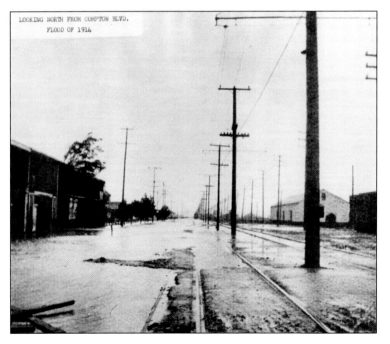

This 1914 photograph shows the flooded west side of Willowbrook Avenue looking north from Compton Boulevard as the camera follows the Pacific Electric Railroad tracks.

Pictured is the flooded east side of Willowbrook Avenue looking north from Compton Boulevard in the 1914 flood.

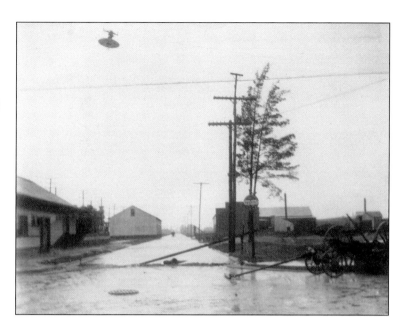

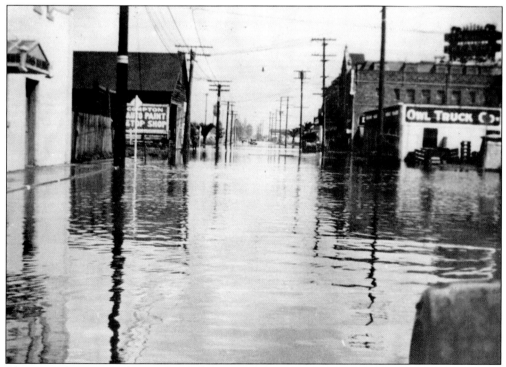

This 1916 photograph shows a flooded Tamarind Street from Compton Boulevard looking north toward Magnolia Street. On the left is the Compton Auto Paint and Top Shop, and to the right is the Symphony Theatre that was destroyed in the 1933 earthquake. In the foreground is the Owl Truck & Materials Co.

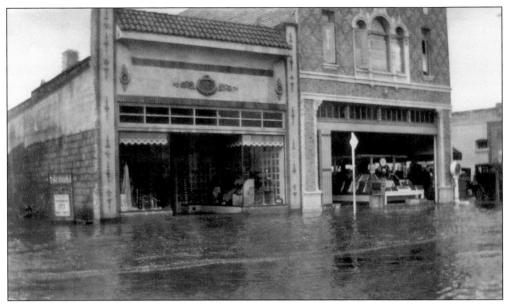

Flooded businesses are seen here in Compton in 1926. The sign on the left announces a performance and gift night at the Symphony Theatre.

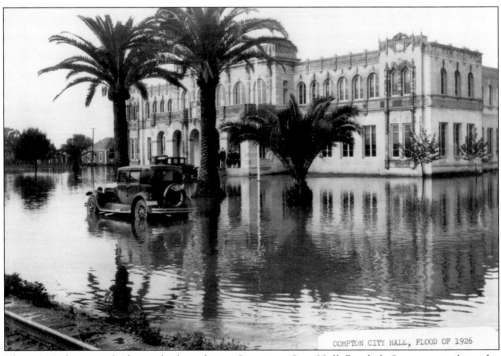

This 1926 photograph shows the brand-new Compton City Hall flooded. Cars are stuck in the water, and there is a group of people on the city hall steps.

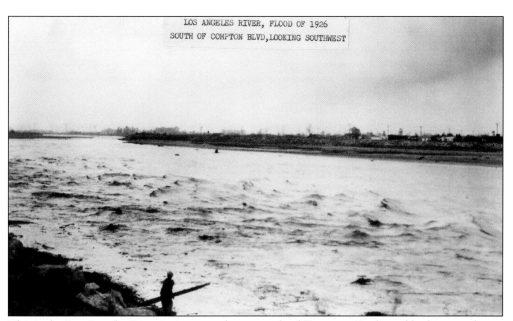

This is the Los Angeles River in its natural state south of Compton Boulevard looking southwest during the flood of 1926.

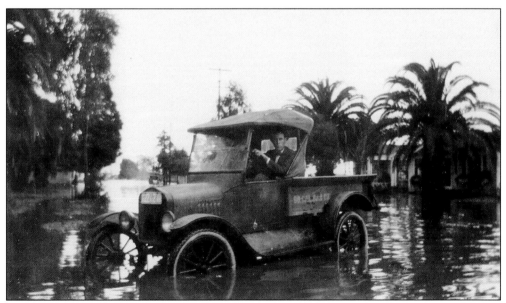

A 1926 photograph shows a young man in a Southern California Gas Company truck going through a flooded street in the city of Compton.

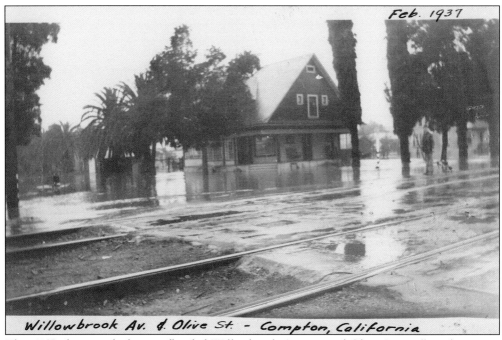

This 1937 photograph shows a flooded Willowbrook Avenue and Olive Street (later known as Alondra Boulevard). In the background is the Mears-Black house.

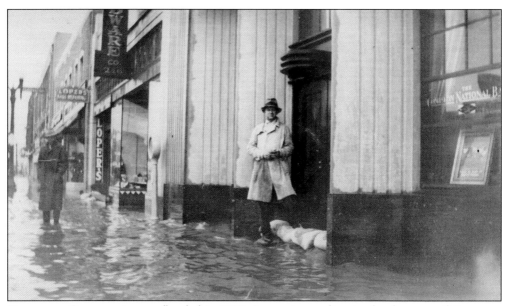

Downtown Compton is seen flooded in 1937. A man is standing in the doorway of Compton National Bank (Security First Bank building). Pictured also is Compton Boulevard east of Tamarind Street.

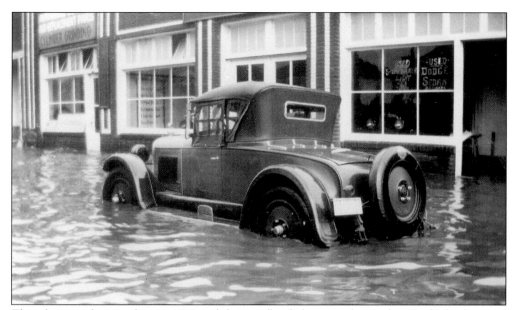

This photograph was taken in 1926 and shows a flooded-out mechanic shop in the background and a brand-new car stuck in the water. The periodic floods were becoming an obstacle to the Compton business community.

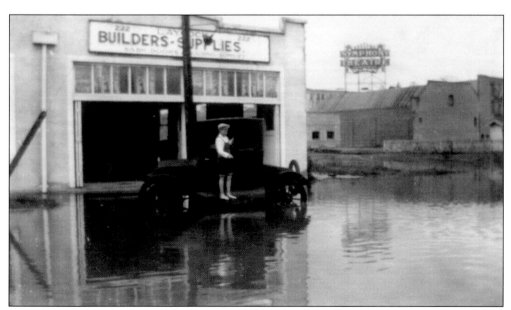

A young boy plays on a car in Compton in the 1926 flood. In the background is the sign for the Symphony Theatre.

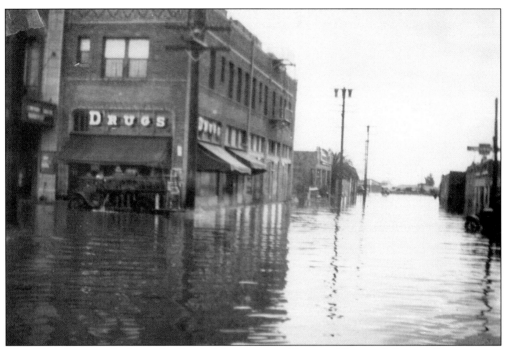
This 1926 photograph shows the flooded drugstore on Tamarind Street. A fire truck is trying to pump floodwaters out of the building.

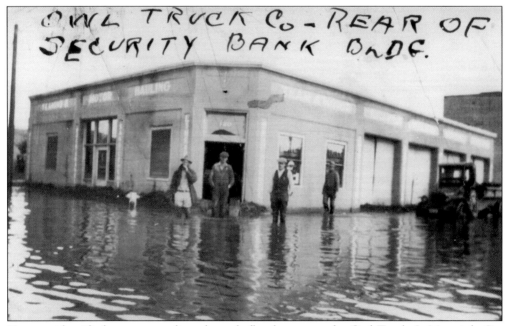
Here, unidentified men are wading through floodwaters at the Owl Truck & Materials Co. Tamarind and Magnolia Streets and the Security First Bank building are in the background on the right. This photograph was taken in 1926.

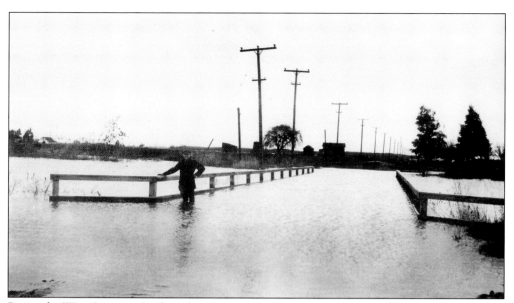
Pictured is West Compton Boulevard at Compton Creek just east of what would become Wilmington Avenue in 1914. The creek is flowing over the bridge, and the man posing for the camera has water up to his knees.

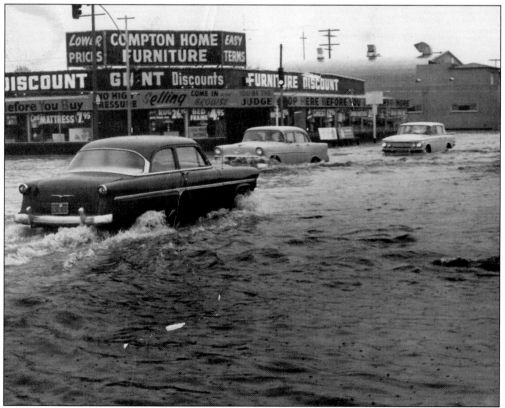
This 1958 photograph shows a flooded Compton Boulevard intersection in front of the Compton Home Furniture store.

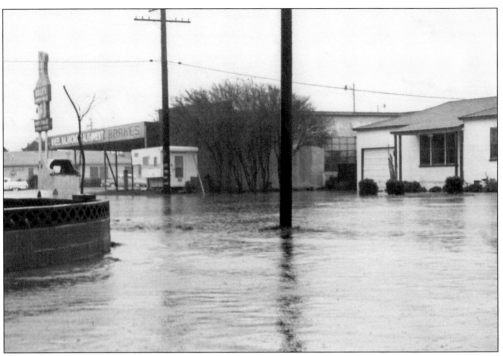

Indigo Street in Compton just east of Long Beach Boulevard is seen flooded here in 1959. The business to the right is still in operation as of January 2012.

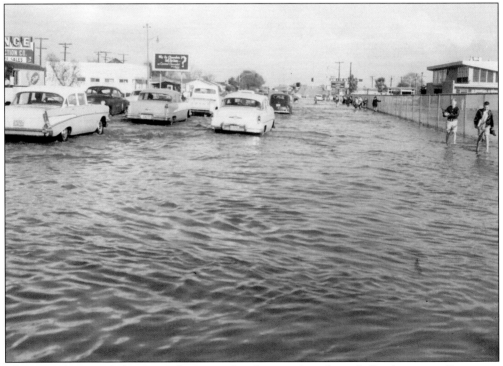

This 1958 photograph shows cars driving and students wading through floodwaters on Rosecrans Boulevard looking east. Whaley Junior High School is on the right.

Workers are seen in 1950 building the East Compton Drain to help alleviate flooding in the city of Compton. This picture is looking south along Santa Fe Avenue from Palmer Avenue.

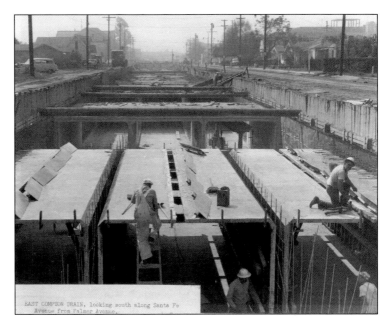

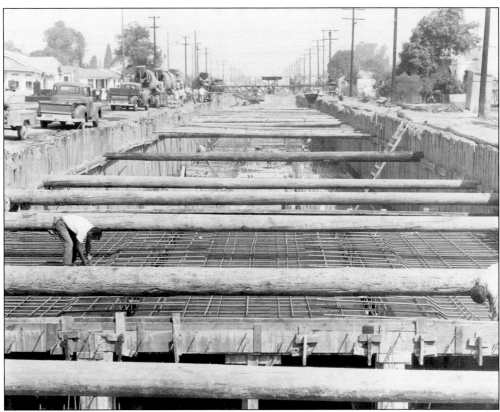

This 1950 photograph shows workers building the East Compton Drain, which looks north along Santa Fe Avenue from Palmer Avenue. Cement trucks and houses are along the left side of the street. An underground river runs under Santa Fe Avenue during the rainy season.

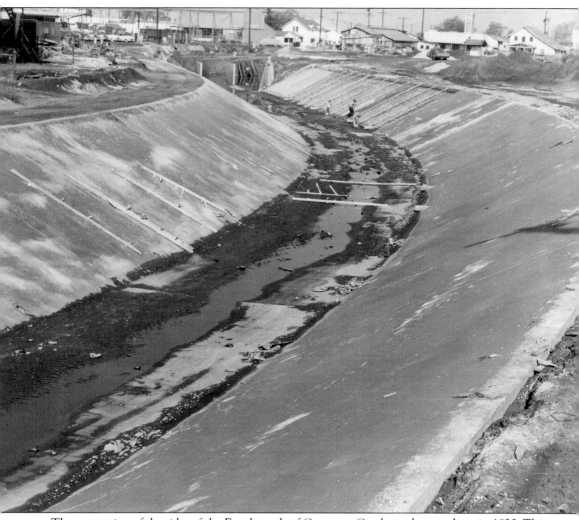
The cementing of the sides of the East branch of Compton Creek can be seen here in 1930. This view is looking northwest from south of Olive Street (now known as Alondra Boulevard).

Six

EARTHQUAKE!

At 5:54 p.m. on March 10, 1933, a magnitude 6.4 earthquake struck the city of Compton, which lies on the Newport-Inglewood Fault. The epicenter of the quake was three miles south of Huntington Beach and about eight miles deep. In Compton, almost every building in a three-block radius was destroyed. Damage to the schools was severe, and had the earthquake struck a few hours earlier when school was in session, the amount of casualties would have been tremendous. As it was, 120 people lost their lives in the earthquake, and 15 people died in Compton. The massive destruction of schools in Compton led to the state legislature passing the Field Act, which regulates school-building construction in California. Since the Field Act, no school has collapsed because of an earthquake, and there has been no loss of life. After years of progress, the destruction of the business district and the schools in the city was a tremendous blow to the residences of the city of Compton. But within weeks, the cleanup had begun, the business district was relocated, and life was beginning to return to normal.

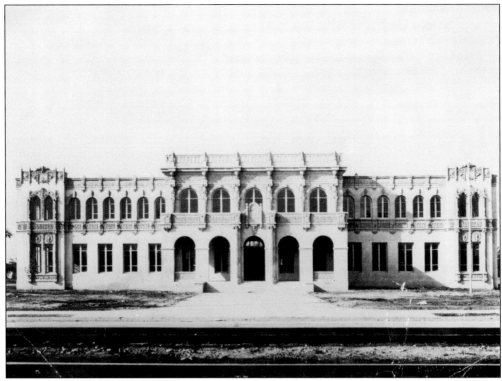

This 1925 photograph shows Compton's first city hall next to the Southern Pacific Railroad tracks on Willowbrook Avenue.

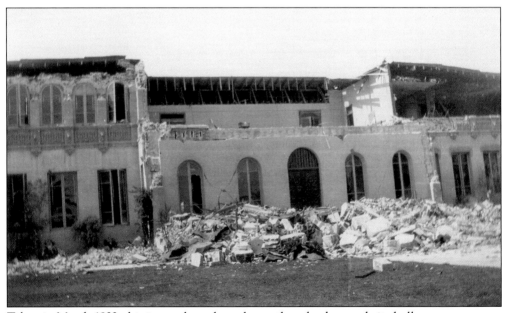

Taken in March 1933, this image shows how the earthquake damaged city hall.

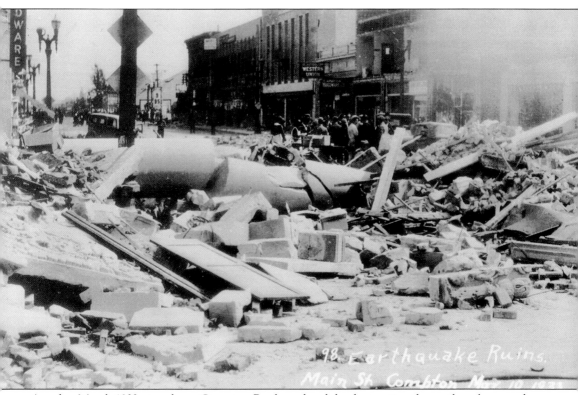

Another March 1933 view shows Compton Boulevard and the destruction the earthquake caused on the evening of March 10. The photograph looks east from Tamarind Street. Columns from the First Security National Bank lay in the middle of the street. The Western Union shop is visible in the background with onlookers taking in the scene.

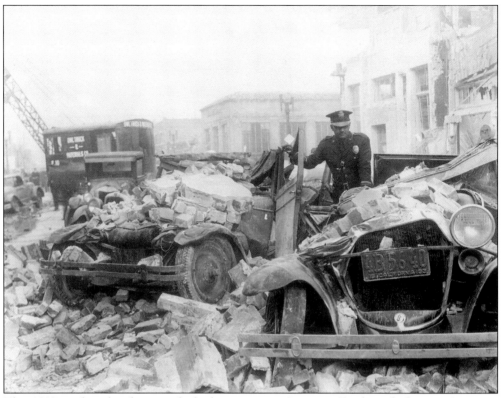

This 1933 earthquake photograph, looking west on Compton Boulevard, shows a Compton police officer examining crushed cars for casualties. In the background, a crane from Owl Truck & Materials Co., a local business, helps with cleanup efforts.

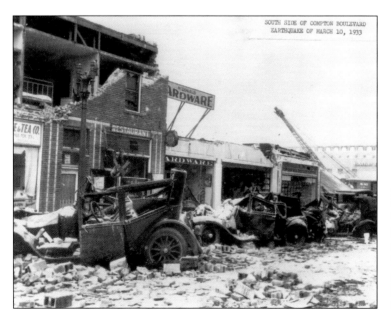

Another image, looking east on Compton Boulevard, shows a row of smashed cars parked in front of Fargo Tea and Coffee Company, McDonald Hardware, and other businesses.

In the rubble of Compton's Masonic Temple and post office, one can see the stairs and bathrooms from the side of the building after the 1933 earthquake.

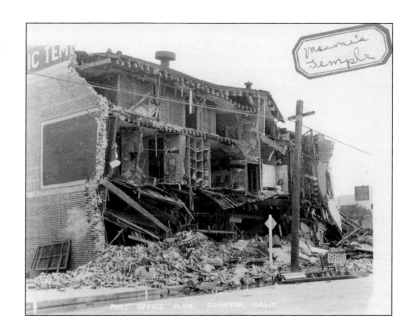

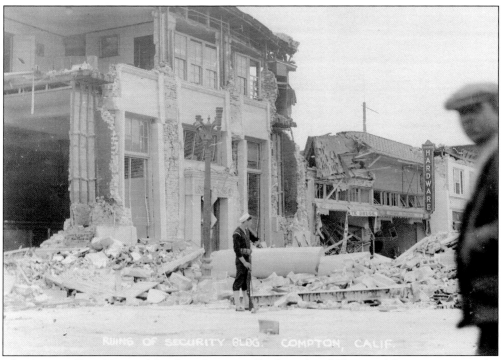

The Security First National Bank at Compton Boulevard and Tamarind Street is seen in the aftermath of the earthquake. A US Navy sailor stands guard over the rubble.

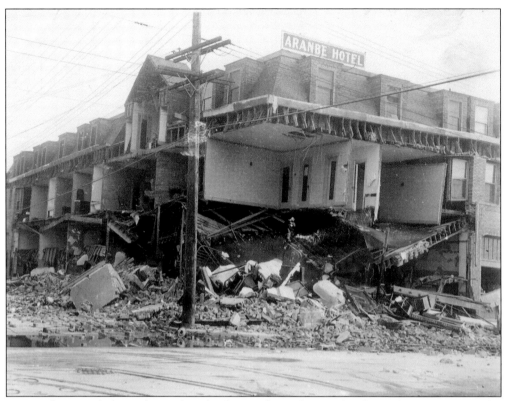
A 1933 photograph shows the earthquake-damaged Aranbe Hotel and Symphony Theatre at the corner of Tamarind and Magnolia Streets.

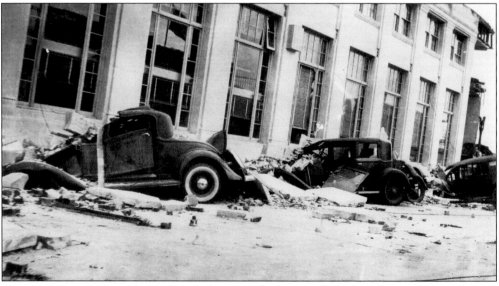
Compton's Security First National Bank shows smashed cars at the bank building after the disaster. Most of the people who lost their lives were killed by falling debris.

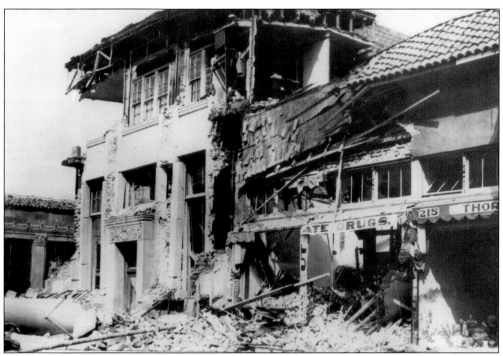
The Tamarind Street entrance to Compton's Security First National Bank is seen here. Cut Rate Drugs is visible on the right.

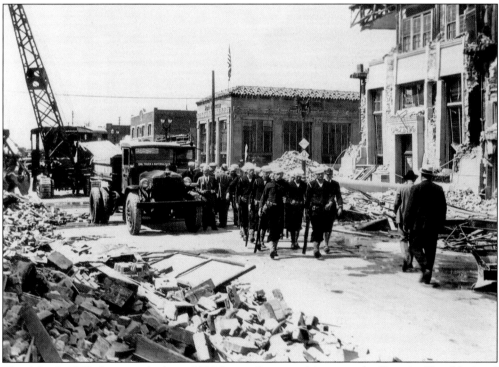
This March 1933 photograph shows US Navy sailors marching past the Security First National Bank building at the corner of Compton Boulevard and Tamarind Street.

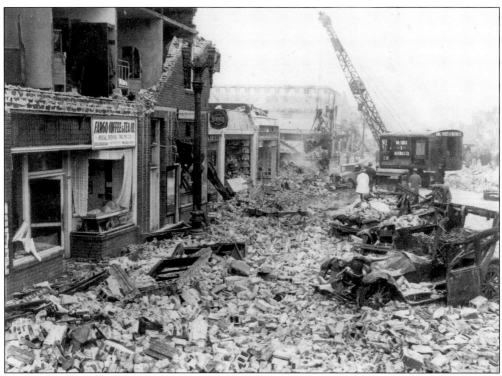

A view looks east from the Pacific Electric Railroad tracks at Willowbrook Avenue, showing Compton Boulevard covered in rubble and smashed cars from the Fargo Coffee and Tea Company building.

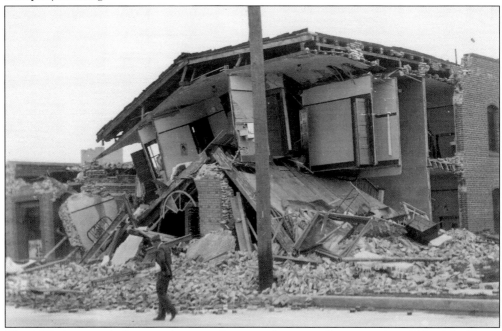

This 1933 photograph shows an American Legion volunteer walking past the rubble of the Young hotel on Willowbrook Avenue.

Pictured are Compton Boulevard (formerly known as Main Street) and the Security First National Bank. On the left are smashed cars, and the crane is visible on the right. This photograph shows the danger of falling debris during the earthquake.

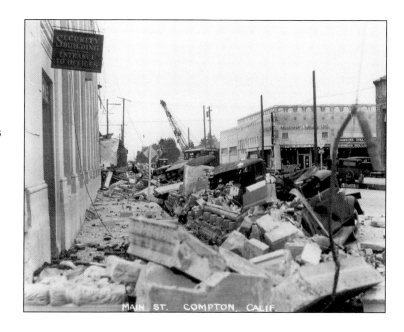

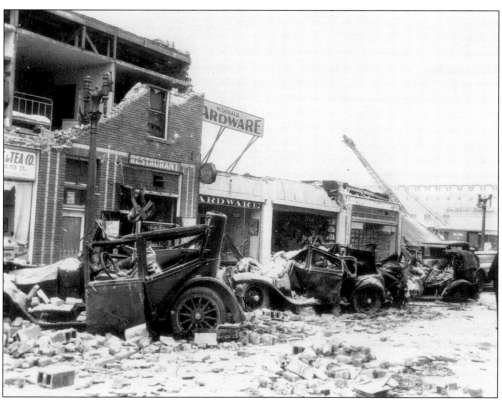

The devastation is clear looking east on Compton Boulevard with smashed cars parked in front of Fargo Tea and Coffee Company, McDonald Hardware, and other businesses.

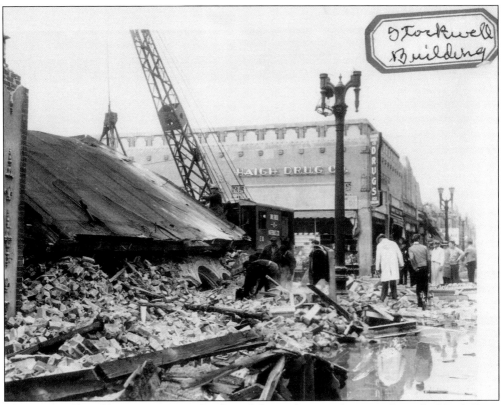

The Stockwell Building on Compton Boulevard, located across the street from the Heigh Drug Company building, was totally destroyed by the March 1933 earthquake. The Stockwell family had been doing business in Compton prior to 1900.

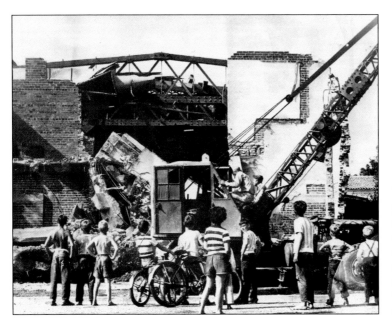

This 1933 photograph depicts children watching a demolition by crane of a building with a collapsed wall and roof. By this time, the earthquake cleanup had begun.

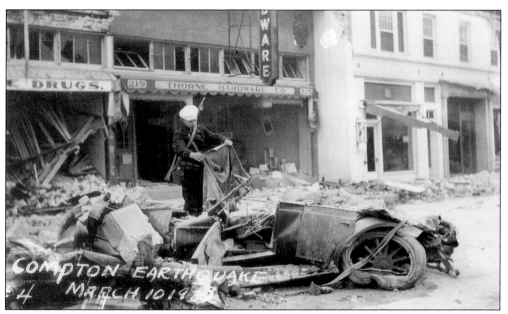

Pictured are Cut Rate Drugs and Thorn Hardware on Tamarind Street. A US Navy sailor is covering the body of a victim after the March 1933 earthquake.

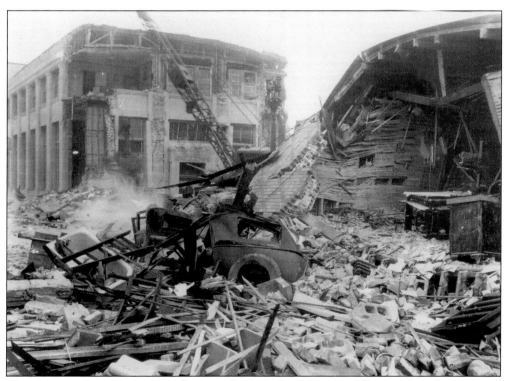

This photograph looks north to Compton Boulevard and Tamarind Street at smashed cars and collapsed buildings. The crane on Tamarind is removing earthquake rubble.

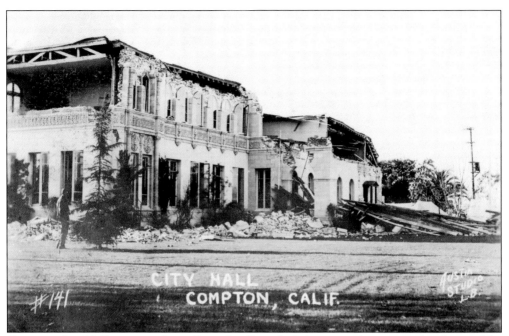

Compton City Hall is seen with a collapsed wall on the left wing and a near-total collapse of the right wing with debris around the building. A man standing in the left foreground seems to be surveying damage.

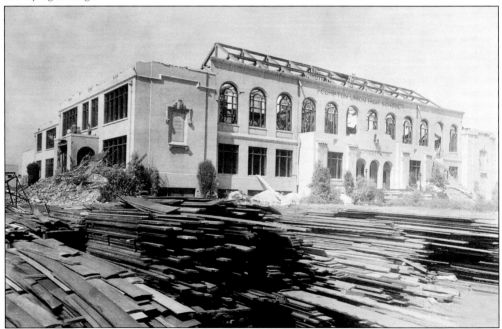

The Compton Union High School and Junior College Administration Building was gutted because of earthquake damage and rebuilt. Because the devastating earthquake took place after school hours, many children's lives were spared. The massive failure of school buildings throughout the region gave rise to new laws and regulations in the reconstruction and building of schools throughout the state with the city of Compton leading the way.

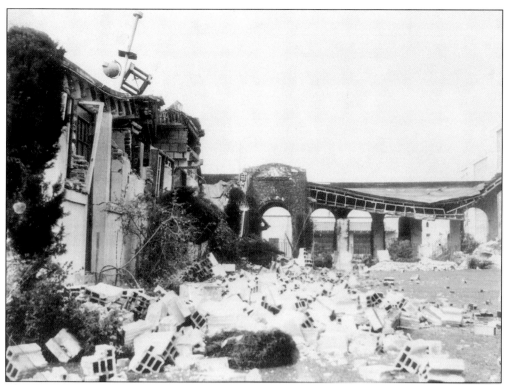

This is Compton Union High School and Junior College after the 1933 earthquake. The photograph depicts the north side of the patio, showing the collapsed roof and walls. After viewing the destruction, it became clear that new laws and regulations governing the building of public schools had to be enacted.

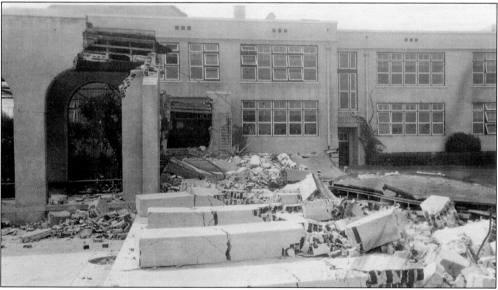

Pictured here is Compton Union High School and Junior College after the March 1933 earthquake. This is the north arcade showing the collapsed columns. Hundreds of students would have been killed or injured by falling debris if the earthquake had taken place a few hours earlier.

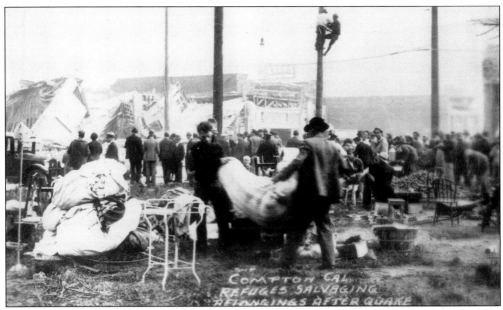

Compton residents salvage their belongings after the March 1933 earthquake; people in a park are going through linens, furniture, and other items, as men on a power pole reconnect electricity.

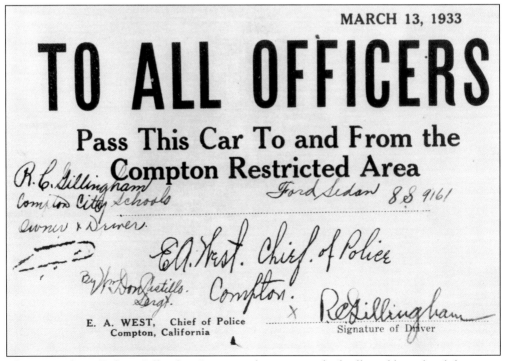

This image shows Robert Gillingham's restricted area pass, which allowed him the ability to go into restricted areas and ascertain the damage to Compton schools.

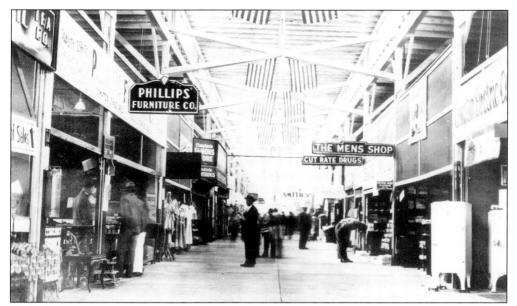

With the destruction of the Compton business district, resourceful Compton residents relocated their business district to the former Rabbit Show Building on Alameda Boulevard, located north of Rosecrans Boulevard. This 1933 image shows that even after a devastating earthquake, the Compton business community survived.

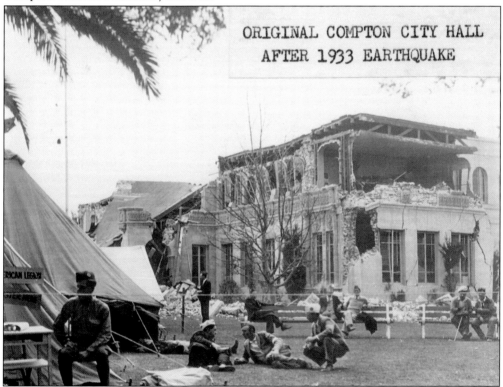

Here is a side view of Compton City Hall after the 1933 earthquake. There is an American Legion camp and volunteers in the foreground.

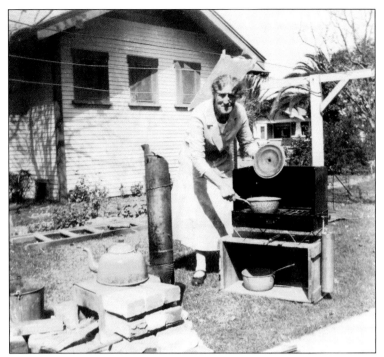

For weeks after the 1933 earthquake, many people slept and ate outdoors for fear of another earthquake and escaping gas. This photograph shows Mrs. Ward preparing food on an outdoor stove.

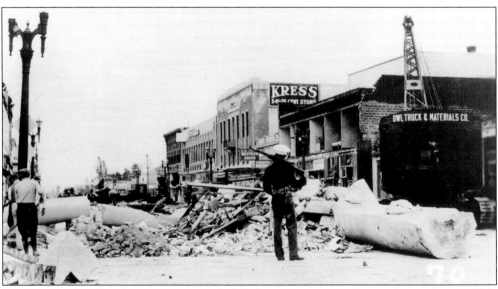

After the earthquake, the US Navy patrolled for looters. Here, a sailor stands guard over rubble on Main Street. In the background stands Kress 5-10-25 Cent Store. A crane is on the right and so is the Owl Truck & Materials Co., a local Compton business.

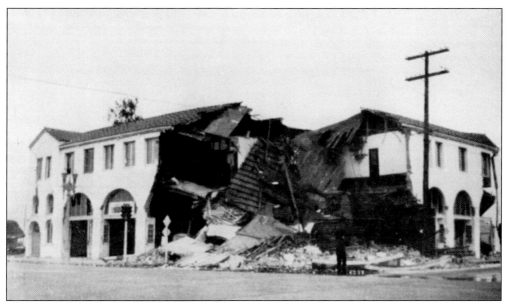

This 1933 photograph shows the collapsed roof and extensive earthquake damage to a large market at the corner of Main Street (Compton Boulevard) and Long Beach Boulevard.

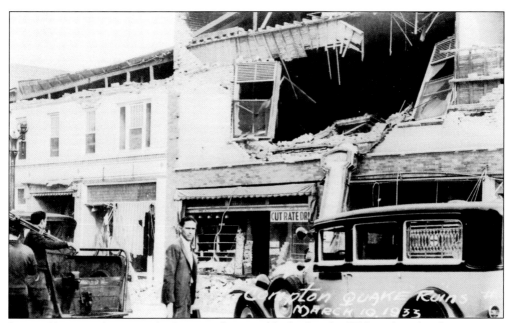

Pictured here are the ruins of a Compton business block after the 1933 earthquake; the extensive upper floor damage is visible. Residents of the city of Compton would have to remove the rubble of the destroyed downtown and begin rebuilding.

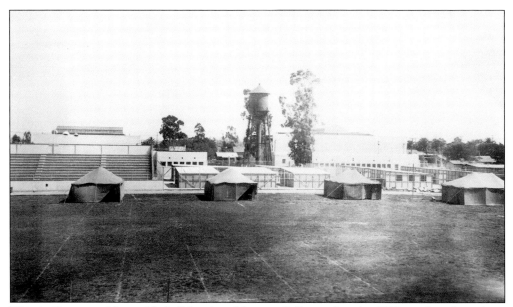

This is Compton Union High School and Junior College after the 1933 earthquake, where temporary classrooms were held in tents on the athletic field. Damaged buildings can be seen in the background.

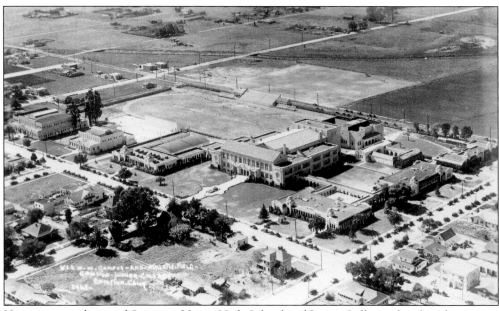

Here is an aerial view of Compton Union High School and Junior College taken less than a year before the devastating March 1933 earthquake. In the background, one can clearly see Compton Creek and Olive Street (Alondra Boulevard) in the upper left portion. Richland Farms and the area north of Olive Street were part of Harmon Higgins's land that would become known as Victory Park in the 1940s, a housing project for defense workers during World War II.

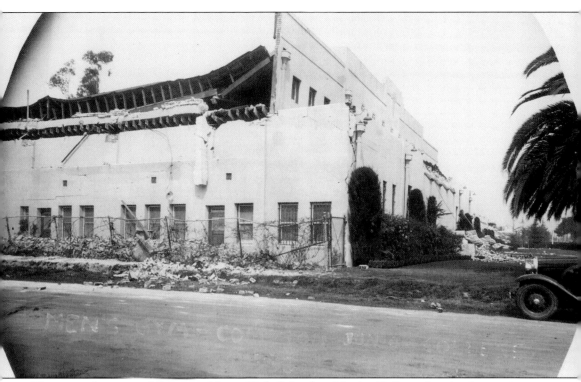

This is another view of Compton Union High School and Junior College after the devastating earthquake. The photograph shows the destruction of the men's gym and the collapsed roof. Because the earthquake took place late in the day, the lives of many students were spared. As a result of the massive failure of its school buildings, the city of Compton led the way in school-building reform in the state of California.

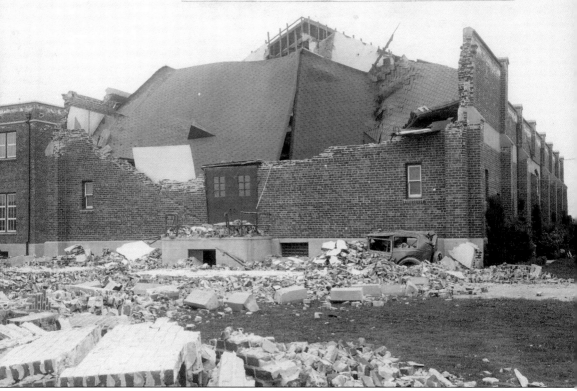

Pictured is Roosevelt Junior High School, which was destroyed by the March 1933 earthquake. This 1933 photograph shows the destruction of the school auditorium. Notice the car smashed by the rubble.

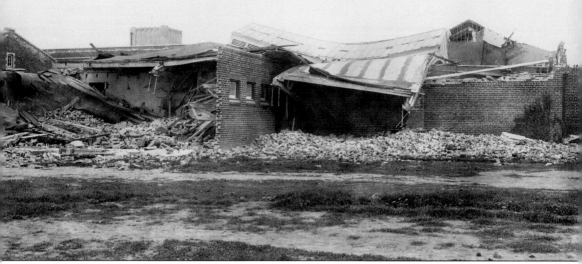

Compton's Roosevelt Junior High School suffered extensive damage in the earthquake. Seen is the boys' gymnasium with the collapsed roof and walls, and it is apparent the devastation that would have occurred had the disaster happened during school hours.

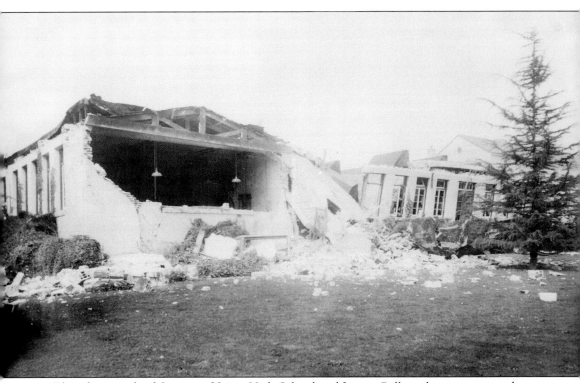

This photograph of Compton Union High School and Junior College shows extensive damage to the shop building with the collapsed roof and wall.

Seven
THE PEOPLE

After the end of the Mexican-American War in 1848, people came to California in search of gold from all parts of the world called forty-niners. Many of the forty-niners who did not strike it rich stayed in California to farm the land. Most of the early settlers who came to Compton in the Compton/Morton wagon train from Stockton were failed gold seekers. They decided to join a Methodist agricultural colony.

Many of these original Compton settlers were from the Midwest. Some were Civil War veterans, and others were just farmers looking for a fertile plot of land. In the beginning, Compton was a temperance town in keeping with its Methodist roots, and saloons were not a welcome business. As the city grew and changed from an agricultural village to a small city, people from different parts of the country settled in Compton. After World War II, many returning veterans made their home in Compton, including two future presidents of the United States: George H.W. Bush and his son George W. Bush. The Bush family lived in the city of Compton in 1949 and 1950 on Santa Fe Avenue.

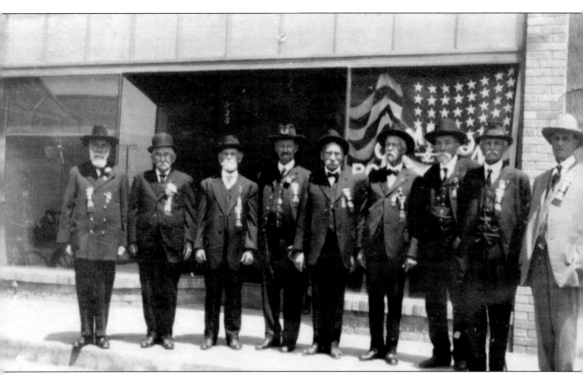

Civil War veterans, members of the Shiloh post (Grand Army of the Republic), pose in front of their meeting hall. The men included members of the Mealey, Flick, Rise, Hann, Kent, and Imbler families.

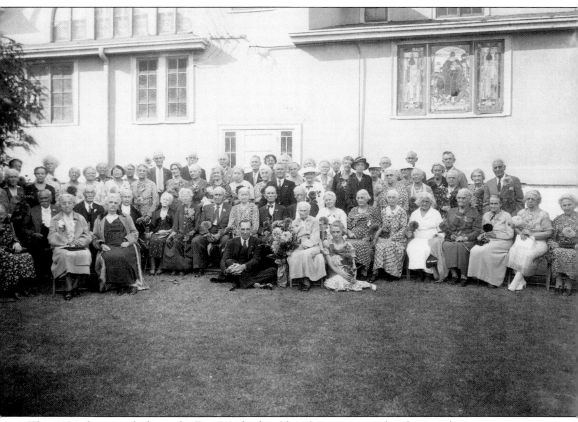

This 1936 photograph shows the First Methodist Church's sunset social gathering, depicting many of the men and women who settled in early Compton. All of the original settlers were members of First Methodist Church.

Two of the early pioneer landowners, John Abbott (left) and George Palmer, are pictured here in 1914 on the front porch of Abbott's home on Compton Boulevard, located east of Alameda Street.

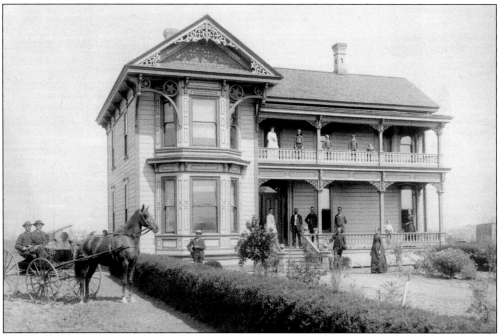

This is the home of early pioneer landowner Harmon Higgins. His house stood near the corner of Olive Street (Alondra Boulevard) and Wilmington Boulevard. Pictured from left to right are (second-floor balcony) Mrs. W.R. Higgins, Mabel Mayo, H.J. "Jeff" Mayo, J.M. Mayo, and Will Mayo; (first-floor porch) Mrs. Joseph Higgins, Dallas Higgins, B.B. Higgins, Clay Mayo, an unidentified boy, and Augusta Mayo; (in front of house) an unidentified men, Harmon Higgins Jr., and Mrs. Harmon Higgins Jr.; (in the buggy) S.J. "Wallie" Higgins and Mr. Knowland (a cousin from Missouri). This photograph was taken in 1900. The land later became the site of the Victory Park federal housing project for World War II defense workers.

The Cressey farmhouse is seen here in the early 1950s. The Cressey family was comprised of pioneer farmers who donated a portion of their land as a park. It was originally called Cressey Park but is now known as Gonzales Park.

This 1900 photograph shows the Black house, which housed one of Compton's pioneering families. The man out front seems to be tending the garden while water sprinklers soak the ground. The woman is enjoying a rocking chair on the porch. Olive Street (Alondra Boulevard) is little more than a dusty road as it crosses in front of the house to meet Willowbrook Avenue.

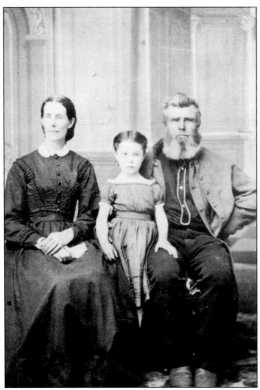

Harmon Higgins poses here with his wife and young daughter. The Higgins family members were pioneer landowners in the city of Compton. Harmon owned the land that would later become Victory Park.

Mr. and Mrs. Sylvester Rogers came to Compton with the original Compton/Morton wagon train from Stockton, California, in 1867. Rogers was the first Sunday school teacher at the First Methodist Church in Compton.

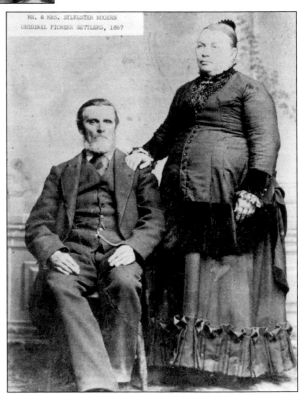

Many Compton residents would recognize George H. Palmer's last name, which is a major street in the city. This is a photograph of Mr. and Mrs. George H. Palmer on their wedding day in 1888, the same year that the city of Compton was incorporated.

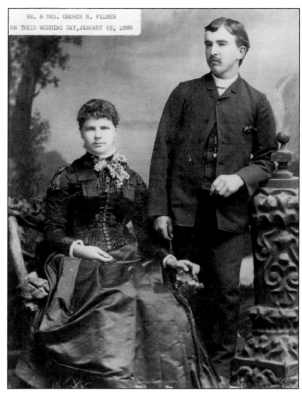

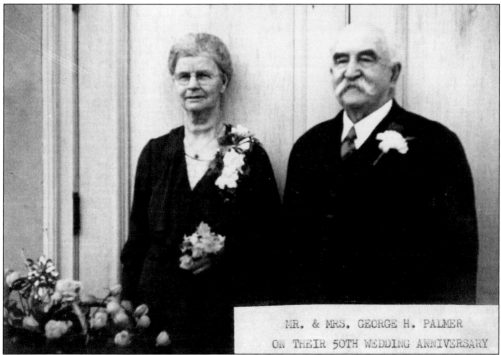

This photograph shows early Compton residents Mr. and Mrs. George H. Palmer on their 50th wedding anniversary 1938.

Pictured is Benjamin Walton, an early Compton landowner. Walton Junior High School (now Benjamin Walton Middle School) is named after him.

This photograph shows Clarence A. Dickison, a longtime Compton resident and mayor of the city from 1925 to 1933. Dickison's daughter Jane Dickison Robbins would become principal of the elementary school that bears his name in 1968. By the 1980s, she would become a city council member, following in the footsteps of her father.

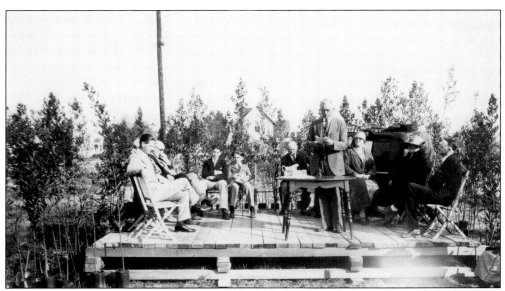

Here, Mayor Clarence Dickison is speaking at a tree-planting ceremony for a new housing tract at the corner Long Beach Boulevard and Alondra Boulevard. On stage are men, women, children, and a piano. This 1927 photograph heralds the end of an agricultural town and the beginning of a suburban city.

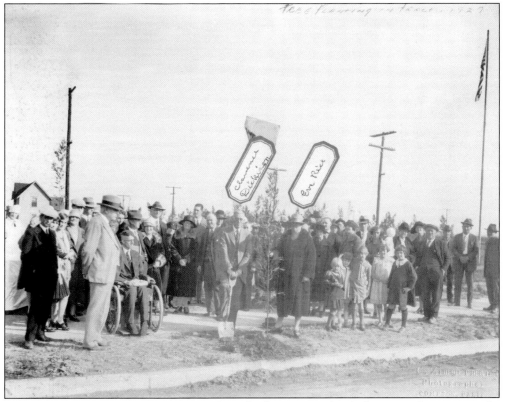

Mayor Clarence Dickison and Eva Rice, from the former Rice family farm, are planting trees for the new housing tract as the crowd watches.

As the city began to grow and more homes were needed, local businesses such as Central Lumber Company found that business was booming. This 1930 photograph shows a loaded truck and car in front of the Central Lumber Company building on Elm Street and Willowbrook Avenue.

This was part of the Ward family ranch seen in 1900. Standing against the barn from left to right are S.W. McAdam, Nelson Ward, Mildred Ward, Frederick Muskew, and Mr. Ward from Whittier. Nelson would later become Judge Ward.

Eight
From Town to City

Compton had been a successful agricultural community; however, by the mid-1920s, some of the farm families began selling their land for housing developments. Most of the farms in and around the city of Compton became housing tracts. Because of the fertile land, many homeowners had a variety of fruit trees in their backyards. But agriculture began to give way to light manufacturing as the city became more urbanized. Only one area stayed true to the city's agricultural roots, Richland Farms. G.D. Compton wanted a portion of the city to always remain for farming, so he pushed for a zoned area for that use; Richland Farms remains agricultural to this day.

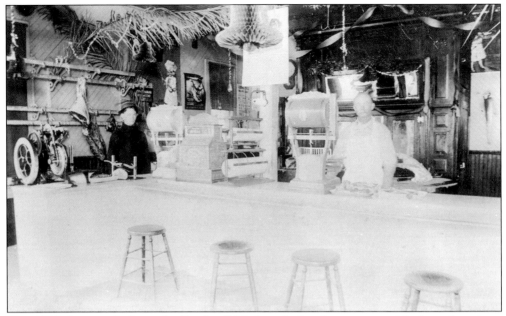

This 1900 photograph shows the Stockwell Market: the butcher counter with the cash register, the meat grinder, and other machines. Meat is hanging from the wall along with a paper bell and streamers.

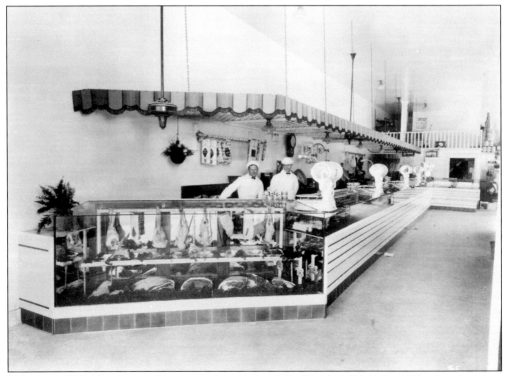

Taken in 1930, this image shows another view of the Stockwell Market. The butchers are behind the counter with scales, and the meat is in the display case here and not hanging from the wall.

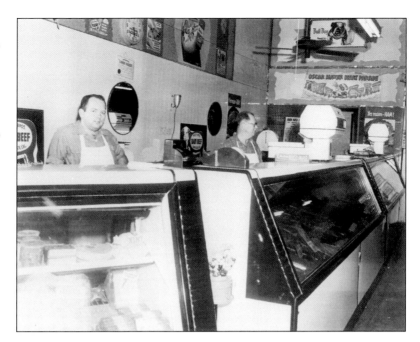

The Stockwell Market is seen in 1957. Proprietors Billy Wayne Stockwell (left) his father, Perry Delbert "Pete" Stockwell (right), worked behind the store's meat and cheese counter. The Stockwell family has been serving residents of Compton since before 1900.

Pictured is the rebuilt Compton Union High School Administration Building. New laws and regulations required schools to be built to withstand moderate earthquakes. This became state law after the enormous damage caused to schools by the earthquake of March 1933.

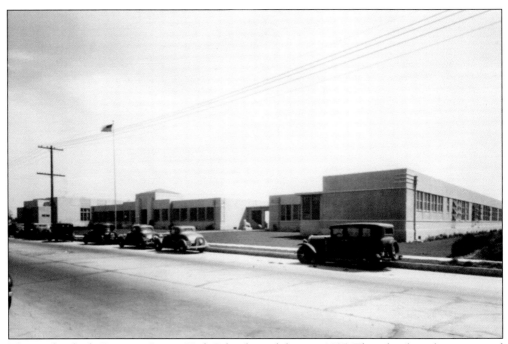

The newly rebuilt Compton Junior High School stands here in 1935. The school was later renamed Franklin D. Roosevelt Junior High School. The new architecture has no overhanging masonry, which was in line with the new school building code.

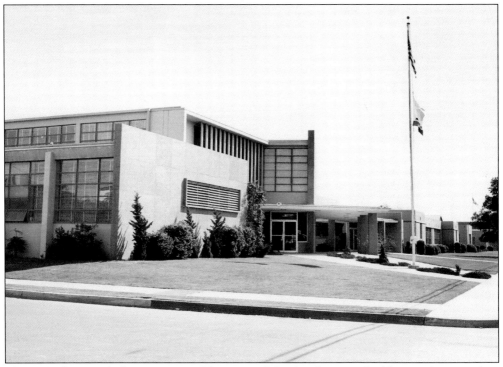

This 1956 photograph shows Compton Elementary School with its new buildings and new modern architecture, which was up to the new earthquake code for schools in California.

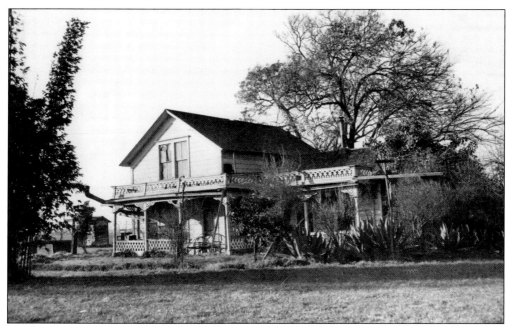

The Taylor house was built by John Taylor around 1875. He was assisted by hired hand Nelson Ward, who hauled the lumber by a mule team from Downey. The house was later occupied by Dr. Francis L. Anton, who planted eucalyptus trees in 1922. In the early 1930s, the home was occupied by Chinese immigrants who operated lottery gambling and an opium den until 1951. The house was later leased to Joseph Camino until the home was torn down to make way for the new Compton Community College.

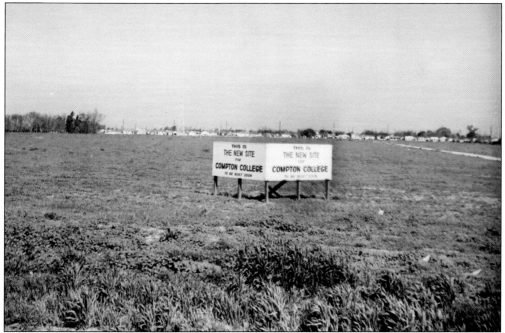

This empty field is the eventual site of Compton Community College. The 1952 photograph is looking north from Artesia Boulevard.

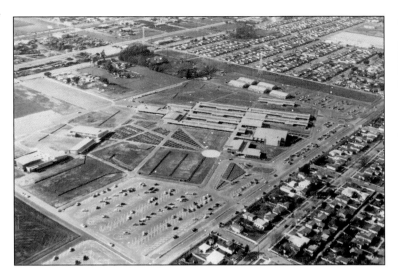

This 1953 aerial photograph, looking northwest, shows the brand-new Compton Community College.

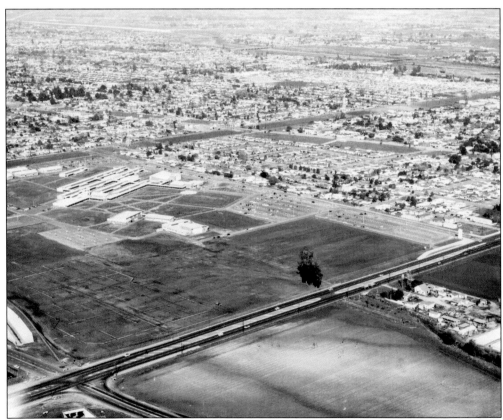

A 1953 aerial image, looking northeast, shows Compton Community College. The bottom left portion of the photograph is the intersection of Santa Fe Avenue and Artesia Boulevard. One can see parts of Compton Creek going under the intersection. In the upper left-hand portion, one can actually see the unfinished concrete lining coming down the Los Angeles River. Portions of the river were still natural at the time.

This photograph shows Compton Community College students standing in front of the bell tower in 1955.

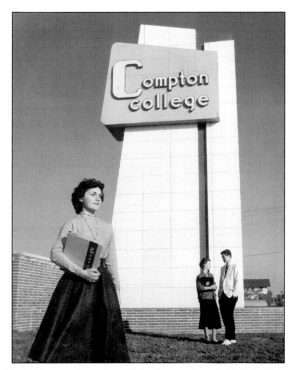

The student lounge at Compton Community College had comfortable couches for students to relax on between classes, as seen here in 1955.

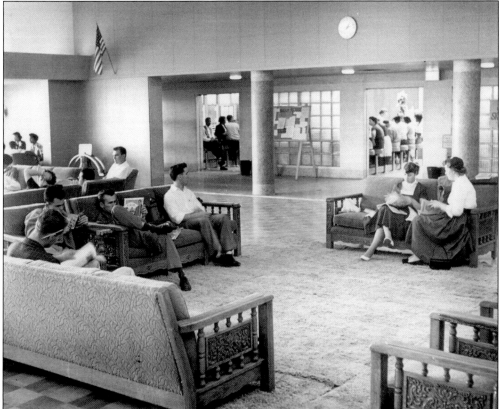

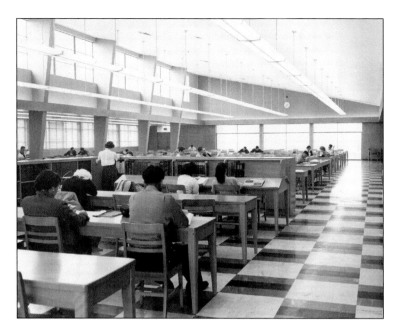

The library interior was sleek, clean, and modern for 1955. There were no computers, microfiche, or smart phones during this time—just a quiet work environment.

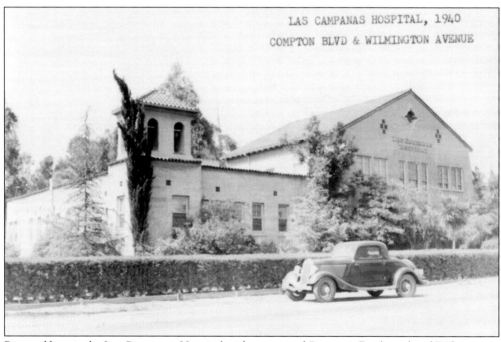

Pictured here is the Las Campanas Hospital at the corner of Compton Boulevard and Wilmington Avenue in 1940. The sanitarium was directly behind the hospital and was a quiet stay for the celebrities who needed to relax for a few days in private.

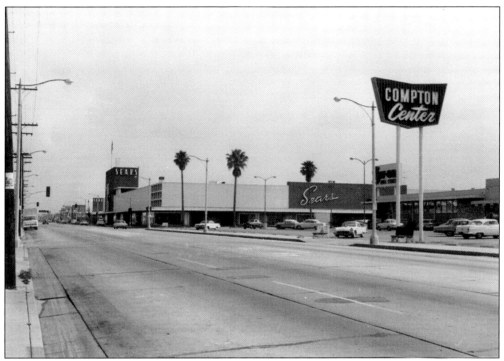

A new shopping center, which had a Sav-On drug store, Sears department store, and a Market Basket grocery store is seen in 1960. The brand-new Compton Center was built on the old Vaughan farm.

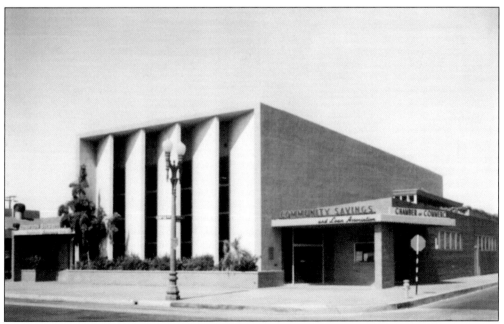

Pictured in 1963 is the Community Savings and Loan Association at the corner of Compton Boulevard and Spring Street. It was also home to the Compton Chamber of Commerce.

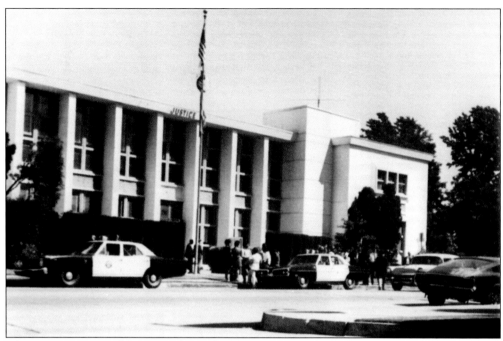

The Compton Courthouse stands in the 1960s. It would later be replaced by a new county courthouse in the 1980s, which would become a regional landmark.

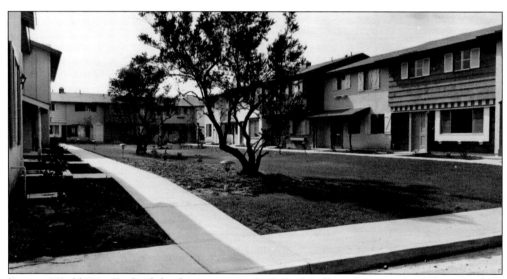

During World War II, the federal government built Park Village, housing for defense workers to ease overcrowding in the Los Angeles housing market. At the end of the war, Park Village was declared a surplus. In 1946, tenets of the project formed the Mutual Housing Association of Compton and bought Victory Park from the Public Housing Administration. The property has been owned and operated by the association since that time in addition to the apartments. Victory Park contains an administration building, an auditorium, and an elementary school. In the early 1960s, it had an all-white occupancy and found itself completely surrounded by the black community.

This 1936 aerial photograph looks northeast through Compton. The farmland has given way to an urban environment. Compton Creek and Compton Union High School and Junior College are in the foreground. The junior college's mascot is the Tartar, a fierce warrior, and the high school's mascot is the Tar Babe, a scimitar-waving, diaper-wearing baby Tartar.

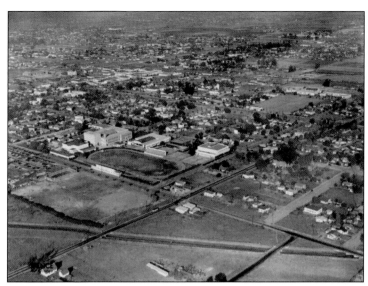

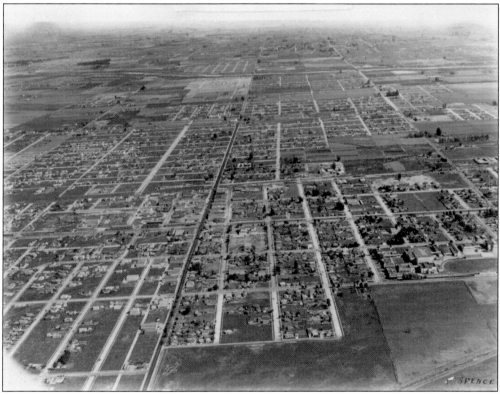

An aerial photograph looks east through Compton and follows Compton Boulevard. Compton Union High School and Junior College can be seen in the lower right. This was taken three years before the devastating earthquake, and much of Compton is still farmland. One can also see the large market that was destroyed in the 1933 earthquake at Long Beach and Compton Boulevards. Also visible are the Symphony Theatre, the banks, and the merchant buildings, which are still standing in downtown Compton on Compton Boulevard. Finally, the back of the original city hall and the library are visible, which were both destroyed by the earthquake.

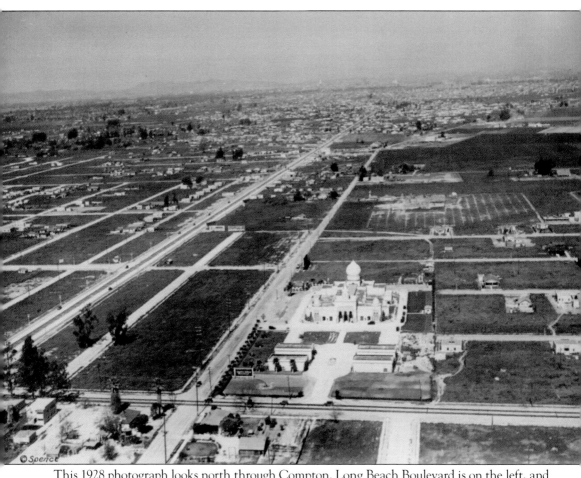
This 1928 photograph looks north through Compton. Long Beach Boulevard is on the left, and the Angeles Abbey Mausoleum is in the center. One can see farmland and open fields, but on the horizon development is inching towards Compton.

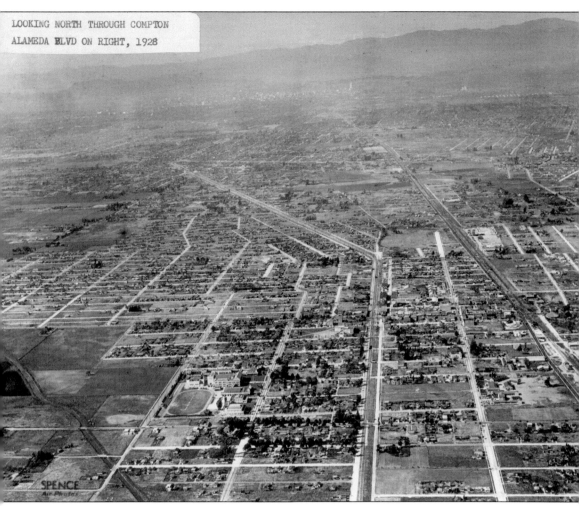

Compton Creek is to the left and Compton Union High School and Junior College are in the lower left center (next to the athletic field) in this 1928 aerial shot.

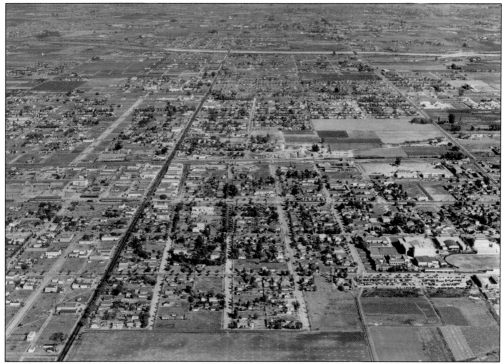

Looking east through Compton, this 1937 image shows a vacant lot where the Symphony Theatre used to be. At Compton Boulevard (dark line left center) and Long Beach Boulevard, there is another vacant lot that was the home of a large market. Both of these buildings were destroyed in the earthquake of 1933. Compton Union High School and Junior College has been rebuilt. One can see cowboy actor Tom Mix's winter quarters in Compton.

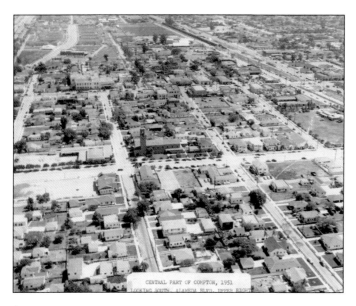

Pictured is the central part of Compton, looking south. To the far left of the picture is Santa Fe Boulevard. The street in the center of the photograph is Palmer Street. At the corner of Palmer and Willow Streets sits our Lady of Victory Catholic Church, which is identified by the steeple. On the southeast and northeast corners of Willow Street sits Our Lady of Victory parochial school. To the far right, Wilson Park with an empty swimming pool can be seen between Rose Street and Alameda Boulevard.

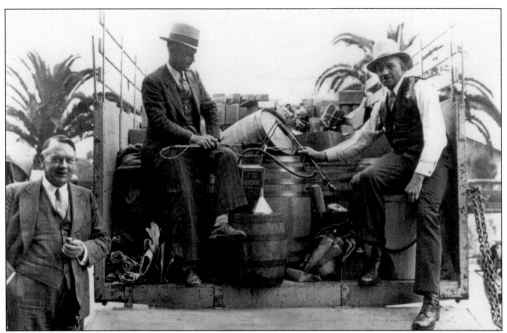

A Prohibition bust is seen in 1931. Sgt. C. J. Andrew (left) is on the truck with City Manager A.C. Gidlley; standing to the left is Chief E.A. West. The city of Compton was founded as a temperance city by members of the First Methodist Church. The city fathers fully agreed with and supported Prohibition.

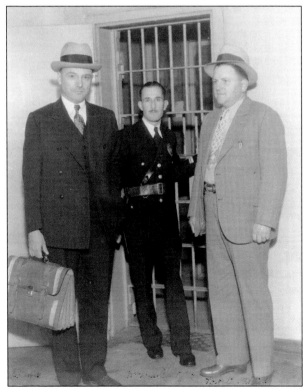

This is a 1933 photograph of vigilant crime fighters S.C. Lewis (left), officer Don Castillo (center), and police chief T.J. Potter.

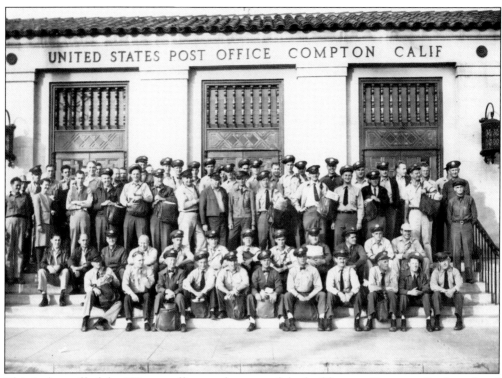

This is the staff of the US post office on the steps of the building on Compton Boulevard and Willowbrook Avenue. This photograph was taken in 1935.

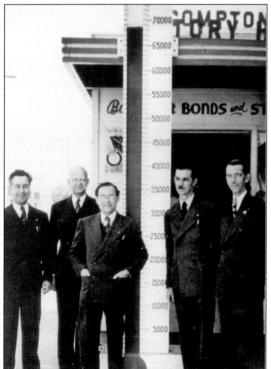

Pictured is the 1944 fundraising thermometer for bond sales during World War II. Compton citizens around the thermometer (from left to right) are Claude W. May, from Bank of America; Frank Whitaker, from Compton National Bank; Al P. Mather, from Compton Junior College; Maurice Burke, from a local drugstore; and John Macy, from J.C. Penney's.

Nine
NEW NEIGHBORS

During World War II, many black people left the South to escape Jim Crow laws. They were in search of a better life and wanted to work in the defense industries of California. With the internment of the Japanese population at the beginning of World War II, many black families found refuge in what was formerly Little Tokyo. Renamed Bronzeville, the area soon became overcrowded. In order to alleviate the crowding in substandard housing, the City of Los Angeles, together with the federal government, built housing projects for defense workers. One of those housing projects was built in Compton, called Park Village; it housed only white families. Other housing projects built in the neighboring communities of Willowbrook and Watts housed mostly black families.

After the US Supreme Court struck down racial covenants in housing, real estate agents took advantage of the pent-up demand for decent housing and began using blockbusting in order to gain listings and sell homes in predominantly white neighborhoods. The most egregious use of this tactic could be found in the city of Compton. This set the stage for racial confrontation and "white flight" that turned into "white panic" after the 1965 Watts rebellion. It led to the destruction of the economic base of the city.

On August 14, 1968, Los Angeles Airways flight 417 had been cleared by Los Angeles helicopter control to take off and proceed eastbound at 10:28 a.m. This was a regularly scheduled flight from Los Angeles International Airport to the Disneyland Heliport in Anaheim, California. At 10:29 a.m., the flight reported to Hawthorne Tower that it was departing Los Angeles eastbound along Imperial Highway at 1,200 feet. At 10:32 a.m., helicopter control advised, "LA 417, seven miles east, radar service terminated." The flight acknowledged, "417, thank you." This was the final radio contact with the flight. The helicopter crashed in Lueders Park in the city of Compton. Many residents tried to save the passengers from the burning wreckage, but unfortunately no one survived. The accident resulted in the loss of 21 lives, including the grandson of the owner of Los Angeles Airways.

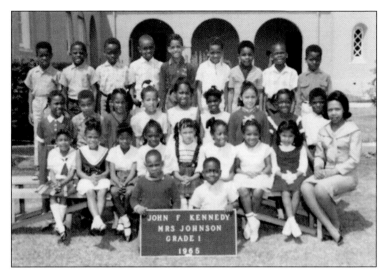

The 1960s brought a demographic change to Compton. This is Mrs. Johnson's first-grade class at John F. Kennedy Elementary School in 1965. (Courtesy of Maceo Reed.)

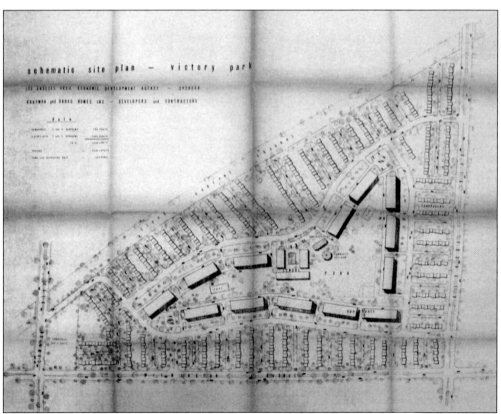

Pictured is the schematic site plan for Victory Park, which was built on land once owned by Harmon Higgins. This white enclave in West Compton felt isolated, and after August 1965 the large-scale migration of whites out of the city was setting in. "White flight" had begun in the early 1960s when realtors began using blockbusting as a tactic to frighten the white population with stories of lower home values and the thought of blacks moving in next door.

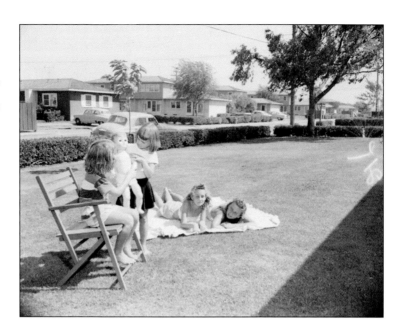

Young children are at play in Victory Park in Compton, California, in 1952. (Courtesy of USC Digital Library.)

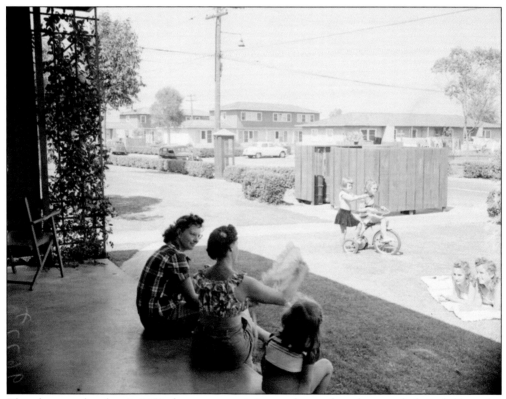

This photograph, taken in 1952, shows women sitting on the porch as they watch their children play in the sunshine at Victory Park, a former government housing project for defense workers during World War II. The housing project was declared a surplus after the war, and it was later purchased by residents who formed a homeowners association. (Courtesy of USC Digital Library.)

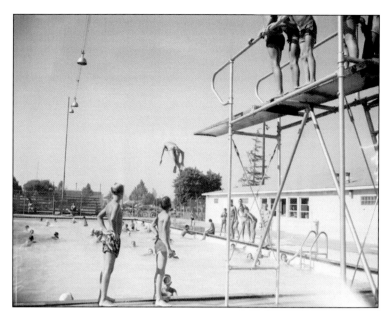

Even though the pool at Wilson Park was not heated, it did not matter on a hot summer day. The water was cold and refreshing, and kids could not wait to jump off the high dive. This photograph was taken in 1952. (Courtesy of USC Digital Library.)

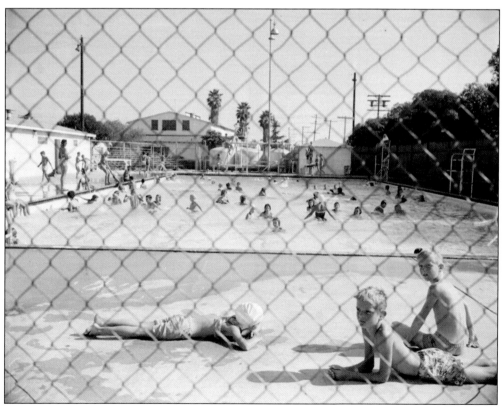

After a cool dip, there was nothing like the feeling of warm concrete on one's cold body watching friends jump off the diving board from the other end of the pool. This image was taken in 1952. (Courtesy of USC Digital Library.)

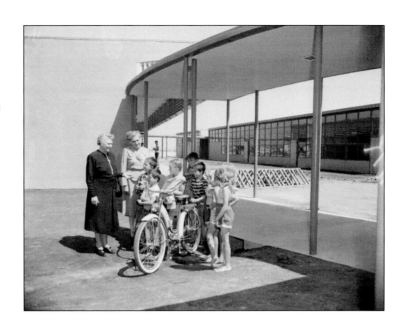

Children are getting a chance to look around at a newly completed school in 1952. (Courtesy of USC Digital Library.)

The Compton Sanitarium was a nice quiet place for the mentally fatigued or if one just needed a private place to dry out from overindulgence of adult beverages. The sanitarium was on Compton Boulevard just west of Wilmington Avenue.

The city of Compton has been home to two presidents, George H.W. Bush and his son (pictured) George W. Bush. They lived in Compton from 1949 to 1950. George's younger sister Robin was born in the city. The Bushes lived on Santa Fe Avenue and found Compton a welcoming place to live, work, and raise a family, as did many veterans of World War II. (Courtesy of George H.W. Bush Presidential Library.)

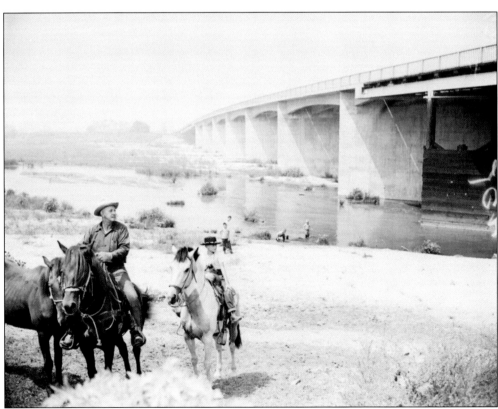

This 1952 photograph shows the brand-new Rosecrans Bridge over the Los Angeles River. Here, the river is still in its natural state, running free and being enjoyed by people on horseback or those who just want to wade in the water.

Maceo Reed Sr. is in front of his newly opened barbershop in November 1956. Reed was a Compton resident and had come to California from Arkansas. As friends and relatives followed in his footsteps, many of them were trained as barbers by Reed. (Courtesy of Maceo Reed.)

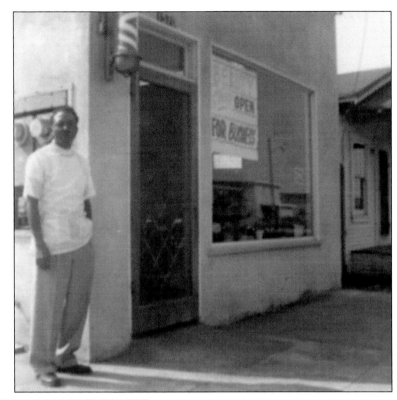

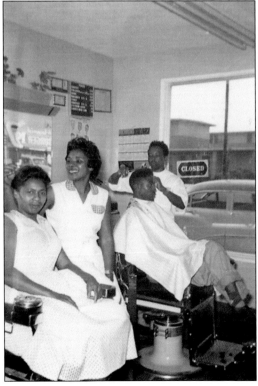

Reed ran a successful business, bought a home, and raised two sons (one of whom followed him into the business). The youngest graduated from the University of Redlands and is currently a mortgage banker. (Courtesy of Maceo Reed.)

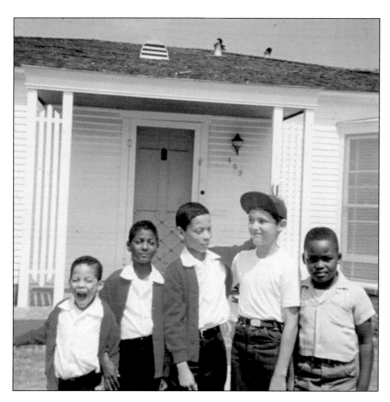

This 1965 photograph shows neighborhood kids at the beginning of the school year in Compton. Pictured from left to right are Kenneth Johnson, Ronald Johnson, Robert Johnson, Michael Gutierrez, and Bobby Powell. (Courtesy of Ronald and Kenneth Johnson.)

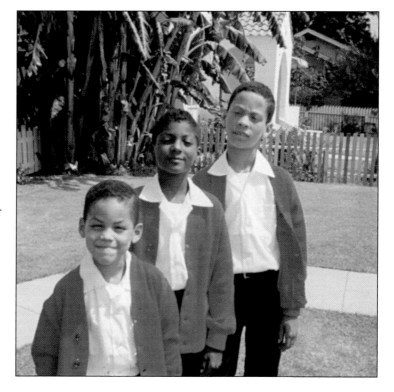

In this image, taken at the end of summer in 1965, Kenneth, Ronald, and Robert say goodbye to summer and get ready to start the new school year in September at Our Lady of Victory Catholic School in Compton. Yes, that is a producing banana tree behind them. (Courtesy of Ronald and Kenneth Johnson.)

Pictured here is Willie Bass painting the house at 409 West Cedar Street in Compton. This photograph was taken in 1965. (Courtesy of Ronald and Kenneth Johnson.)

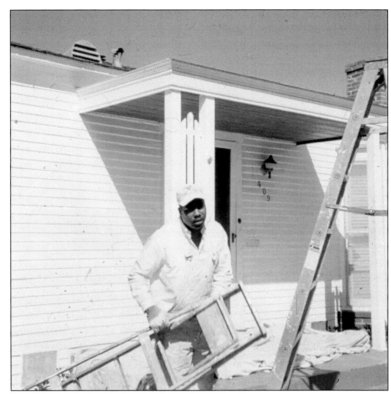

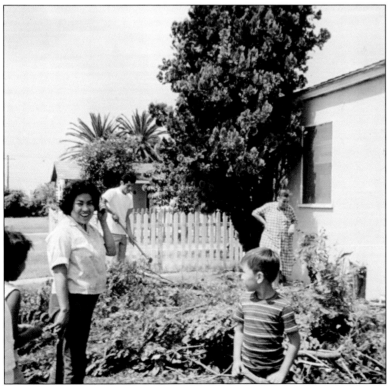

Pictured are Juanita Sanchez and her family working in their front yard next door to 409 West Cedar Street. These homes in 1965 had no bars on the windows, and the front yards are open and not fenced in. (Courtesy of Ronald and Kenneth Johnson.)

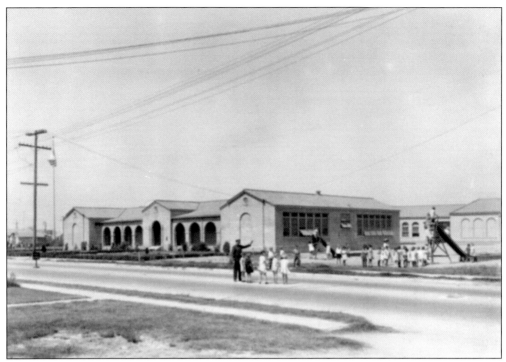

This 1920s image shows General Rosecrans Elementary School, taken before the 1933 earthquake severely damaged the school. After the earthquake, the school was rebuilt. Rosecrans Boulevard (then known as Orange Street) was little more than a country road with very few cars traveling it.

In 1968, the Compton Unified School District opened a new elementary school named after former Compton mayor Clarence Dickison. His daughter Jane Dickison Robbins (front row, center, behind the sign) was installed as principal of the new school. Robbins, whose husband was a Compton police officer, later became a member of the city council, following in her father's footsteps.

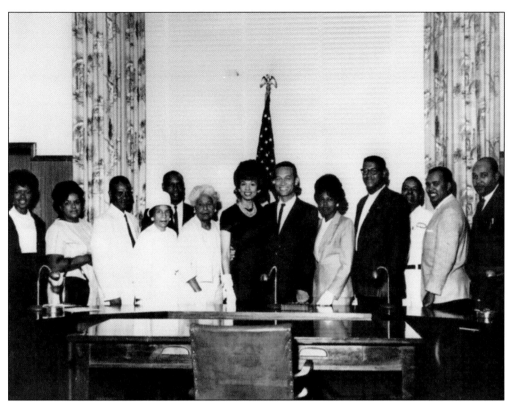

In 1969, the Hon. Douglas Dollarhide became the first elected black mayor of a major municipality in California since United States rule. In the center of the photograph are Mayor Dollarhide and his wife, Ruby. The man wearing glasses fourth from the right is Maxi Filer, known by many as "Mr. Compton." Filer later became a well-known and beloved city councilman. His son Kelvin Filer is a superior court judge at the Compton Courthouse.

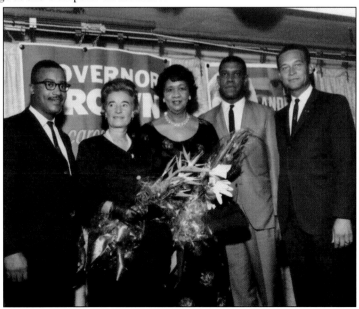

This 1967 photograph shows, from left to right, Leon Ralph, assemblyman; Bernice Brown, wife of Gov. Pat Brown; Dr. Dorothy Height, from the National Council of Negro Women; Bill Green, assemblyman; and Douglas Dollarhide, city councilman of Compton.

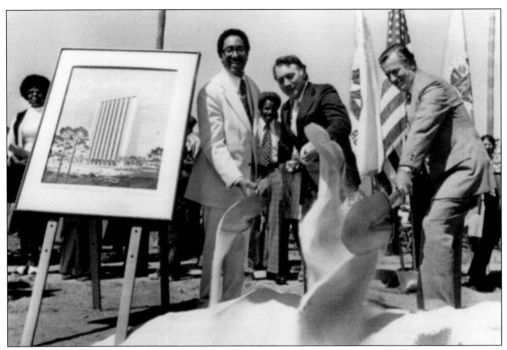

The ground-breaking for the new $27 million Compton Courthouse took place on August 30, 1974. Shown in the foreground from left to right are Dr. Ross M. Miller Jr., Compton city councilman; Supervisor James A. Hayes; and Alfred J. Courtney, presiding judge of the Los Angeles County Superior Court. Miller was the chief of staff at Dominguez Valley Hospital in Compton. He also served as the first black president of the Los Angeles Surgical Society, was president of the Medical, Dental, and Pharmaceutical Association of Southern California, and was a past president of the Southern California chapter of the American College of Surgeons. He chaired the board of Charles Drew University of Medicine and Science. In 1964, Dr. Miller was forced to have a white friend purchase the home he wanted in Compton after a white seller refused to sell to him. His white friend quickly claimed the home to Miller. This incident is what prompted Miller to seek political office. He led the effort to bring a black majority to the Compton City Council.

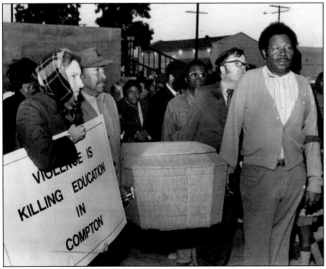

Here, in 1977, Compton citizens protest the rising level of violence in the city of Compton.

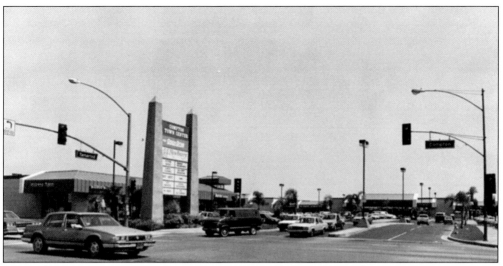
A new downtown in the city of Compton is pictured here in 1988. The Compton Town Center brought shoppers back to downtown Compton.

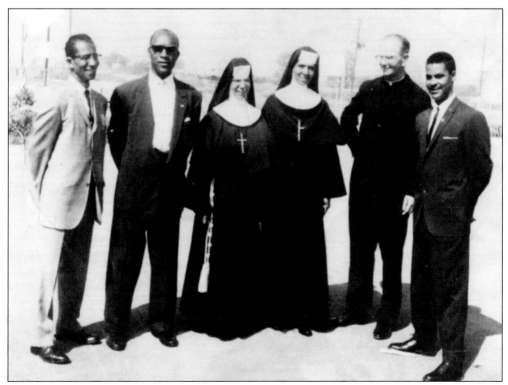
City and church officials gather for the ground-breaking of an all-girls Catholic high school in Compton. Participating in the ceremony are, from left to right, G. Overby, Mr. Gibson, Sister De Salle, Mother Callista, Fr. M. McGovern, and Len Lee. The nuns who would run the school were from an all-black order. This photograph was taken in 1967.

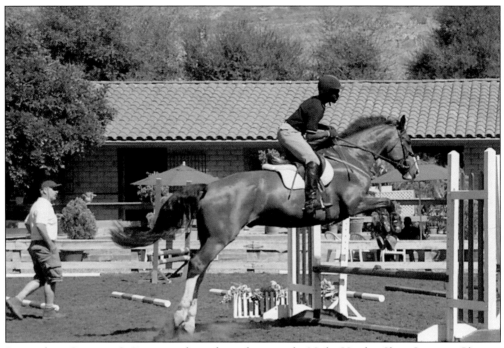

Pictured is a Compton Jr. Posse member riding a horse at the Nicky Hayden Show Jumping Clinic.

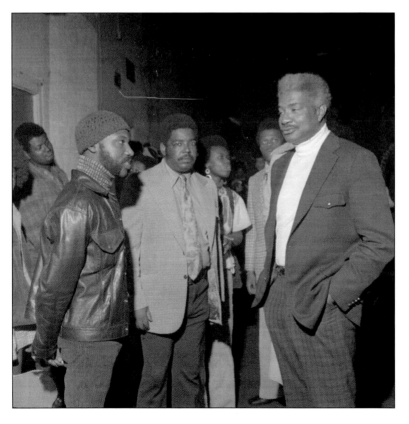

John Outterbridge (left), Leroy Hayes (center), and Ozzie Davis (right) are at an event held by the Compton Communicative Arts Academy in the 1970s.

Without Robert Gillingham (in bow tie), it would have been much more difficult to piece together the history of the city of Compton. Compton was the second American village in Southern California after the American conquest, the first being El Monte. The city of Compton was incorporated in 1888, while the city of El Monte was not incorporated until November 18, 1912. Gillingham kept the history of Compton alive with his research and collection of historical information. His help was invaluable, and the author thanks him. He was definitely a great citizen of the city of Compton.

Compton has always been at the forefront of important history. It was part of the second Spanish land grant awarded to a former Spanish soldier; however, it was the first land grant to be developed. The site was part of a famous battle during the Mexican-American War that denied American forces the retaking of Los Angeles. The first International Air Meet ever held in the United States occurred in Compton in 1910. The laws and regulations, which led to better school construction after the 1933 earthquake, started in Compton. The city has been the place of racial turmoil and urban flight, as well as the birthplace of gangster rap and now rebirth of a city. Compton has always been the "Hub City."

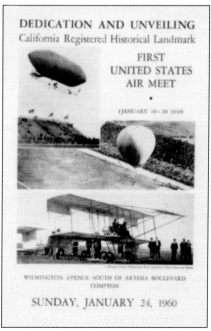

Discover Thousands of Local History Books Featuring Millions of Vintage Images

Arcadia Publishing, the leading local history publisher in the United States, is committed to making history accessible and meaningful through publishing books that celebrate and preserve the heritage of America's people and places.

Find more books like this at
www.arcadiapublishing.com

Search for your hometown history, your old stomping grounds, and even your favorite sports team.

Consistent with our mission to preserve history on a local level, this book was printed in South Carolina on American-made paper and manufactured entirely in the United States. Products carrying the accredited Forest Stewardship Council (FSC) label are printed on 100 percent FSC-certified paper.